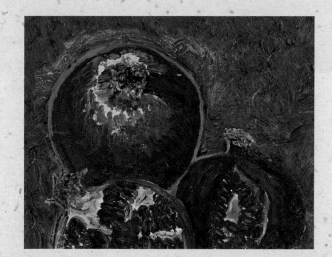

THE *Spirituality*
OF ART

Art... must do something more than give pleasure: it should relate to our own life so as to increase our energy of spirit.

SIR KENNETH CLARK

THE *Spirituality* OF ART

LOIS HUEY-HECK &
JIM KALNIN

Northstone

Kalnin 98

Drumming the Dawn; 1996
JIM KALNIN
Oil on canvas; 69 x 86 cm

Concept: Northstone Team
Editor: Michael Schwartzentruber
Cover: Margaret Kyle
Interior design: Verena Velten
Proofreading: Dianne Greenslade
Art Historian: Carolyn MacHardy
Credits: page 176

NORTHSTONE PUBLISHING is an imprint of WOOD LAKE BOOKS INC. Wood Lake Books acknowledges the financial support of the Government of Canada, through the Book Publishing Industry Development Program (BPIDP) for its publishing activities.

WOOD LAKE BOOKS INC. is an employee-owned company, committed to caring for the environment and all creation. Wood Lake Books recycles, reuses, and encourages readers to do the same. Resources are printed on recycled paper and more environmentally friendly groundwood papers (newsprint), whenever possible. The trees used are replaced through donations to the Scoutrees For Canada Program. A percentage of all profit is donated to charitable organizations.

Library and Archives Canada Cataloguing in Publication
Huey-Heck, Lois, 1957-
The spirituality of art / Lois Huey-Heck & Jim Kalnin.
Includes bibliographical references.
ISBN 1-896836-78-X
1. Spirituality in art. I. Kalnin, Jim, 1942- II. Title.
N8248.S77H84 2006 701'.08 C2006-900015-8

Published by Northstone Publishing
an imprint of WOOD LAKE BOOKS, INC.
9590 Jim Bailey Road, Kelowna, BC, Canada, V4V 1R2
250.766.2778
www.northstone.com
www.woodlakebooks.com

Printing 10 9 8 7 6 5 4 3 2 1
Book printed by Fabulous Printers Pte Ltd., Singapore
Dust jacket printed in Canada

Contents

DEDICATION

To the Sacred, as known to us in and through the following people:

in memory of
Annie Kalnin, November 12, 1919 – May 22, 2005
spirit of unconditional love

Elmar Kalnin – spirit of fairness for all
Diane Huey and Ray Huey – spirits of generosity and service

Bryan Heck, who continues to teach, delight, and surprise us
Family member and friend Steven Heck, who overcame much

and all who are and who have become family to us.

ACKNOWLEDGMENTS AND THANKS

The *Five Elements* Tai Ji, which Lois does as part of her morning practice, includes a series of movements named *woodwind*. Teacher and mentor Hajime Naka said *woodwind* represents everything that has ever been. It includes all the times, places, and people who bring us to the moment that is now. In that spirit, we know that it has taken everyone and everything in our lives (even those that have passed from conscious memory) to bring this project into being.

untitled
JIM KALNIN
38 x 28.3 cm

Our gratitude goes to

Jim's colleagues at The University of British Columbia Okanagan (and Okanagan University College before that), as well as to countless students, friends, and acquaintances in the local art community;

Carolyn MacHardy, art historian UBC Okanagan, for reading the manuscript and catching several of our oversights;

Lois' colleagues at Wood Lake Books – the entire staff; Board; authors; Bonnie, for the idea to do this book; Clare, for her suggestion that we write it; Brenda, copyrights; Margaret, art direction; Verena Velten, design; and Mike, editing;

The *Seasons of the Spirit* team for their commitment to giving the arts their rightful place in spiritual formation; and to Marilyn Perry and *The Whole People of God* team, for teaching the Christian Year;

Merlin Beltain, Donna Sinclair, and Carolyn Pogue, for wise counsel on the inclusion of others' life stories;

The Common Life Community of Naramata Centre, for amazing accompaniment;

Staff and participants of the Pacific Jubilee Program in Spiritual Direction 2004–05 and 2005–06;

The first Jubilee journey group Lois was in (you know what you've done!); Grainger Brown (staff), Tannis Hugill, and Peter Spohn;

Jubilee reader and mentor Murray Groom, for encouragement and insight;

Spiritual Companions/Directors Reverend Patricia Baker, Tim Scorer, Carol Stokes.

Out of necessity, we worked in many settings over the months of writing. In each place, we did our best to be aware of our surroundings as an act of gratitude and as a conscious choice to be nurtured and influenced by the environments themselves. Each place is somehow part of this book, too.

Oblivion; 1994
ANISH KAPOOR
Limestone;
142 x 98 x 145 cm

This is a book of stories presented in the form of words and images. Wherever possible, we've had conversation directly with the artist, but, of necessity, some of the *conversations* have taken place through interviews, books, and artist's statements. Of course, we have also done our best to *converse* with each piece of art in the book.

Some of these stories and images are part of our personal and shared histories and came with us into the project. Some stories we went looking for, through research; and many more found their way to us during the writing of the book. An example of an unexpected visitor has been Mary. We don't pretend to be experts on the significance of Mary the Mother of God (and the full scope of that conversation is *way* beyond this book), yet Mary did *show up* right in the middle of this project. Her appearance carries a sense of synchronicity and purpose and so she has a place here.

We have treated the stories, images, and artists who have come to our attention, as holy guests, and we have endeavored to extend hospitality to these friends and strangers. Even though it has been impossible to include all the stories and peoples who have come to us, they have all informed this project. As people have shared their stories of spirituality and art, they have become like prayers of encouragement saying, "This is a subject that matters." They have been bread for the journey. The forming of this book has been both spiritual practice and spiritual teaching for us.

Neither of us believes that art is *the* only way or even the *best* way for everyone to deepen spiritually. Still, as artists and art-lovers, we experience art as one of the great ways to spiritual insight. In a culture that has been so word-heavy and overly cerebral, and where almost everything has been turned into a commodity for sale and purchase, art and the spiritual impulse are a vital counterbalance.

It is our hope that in these pages you will meet some new artists, new images, and new approaches to making art of the Spirit. While we have endeavored to present a range of styles and approaches, our biases no doubt show. We hope you will be met by images and ideas that offer a range of response from comfort to challenge – all the stuff of life.

We hope that through them you will find windows into the holy.

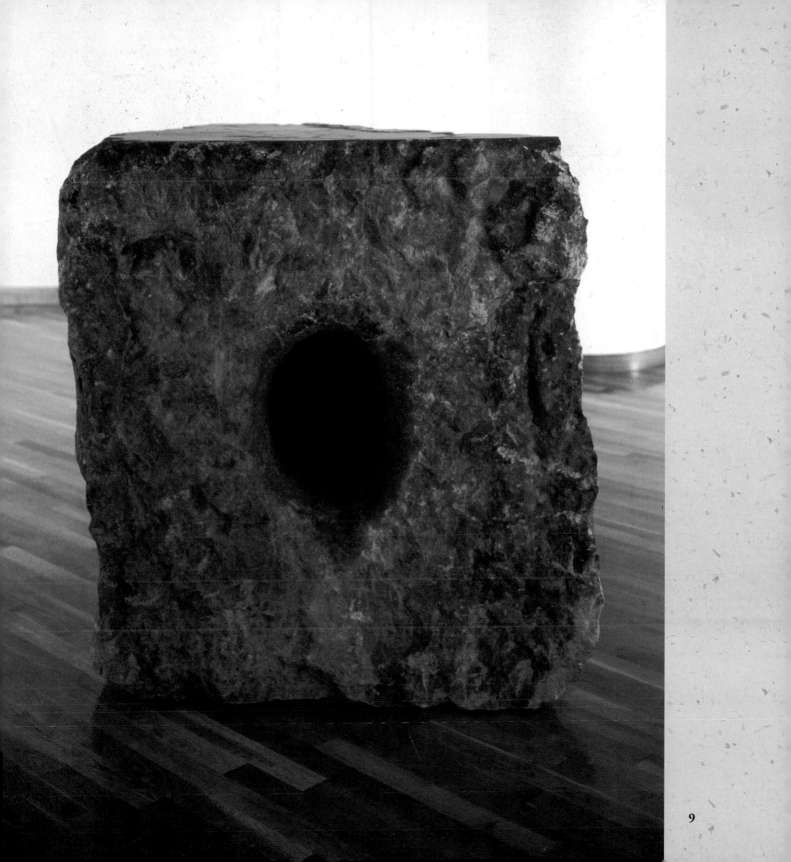

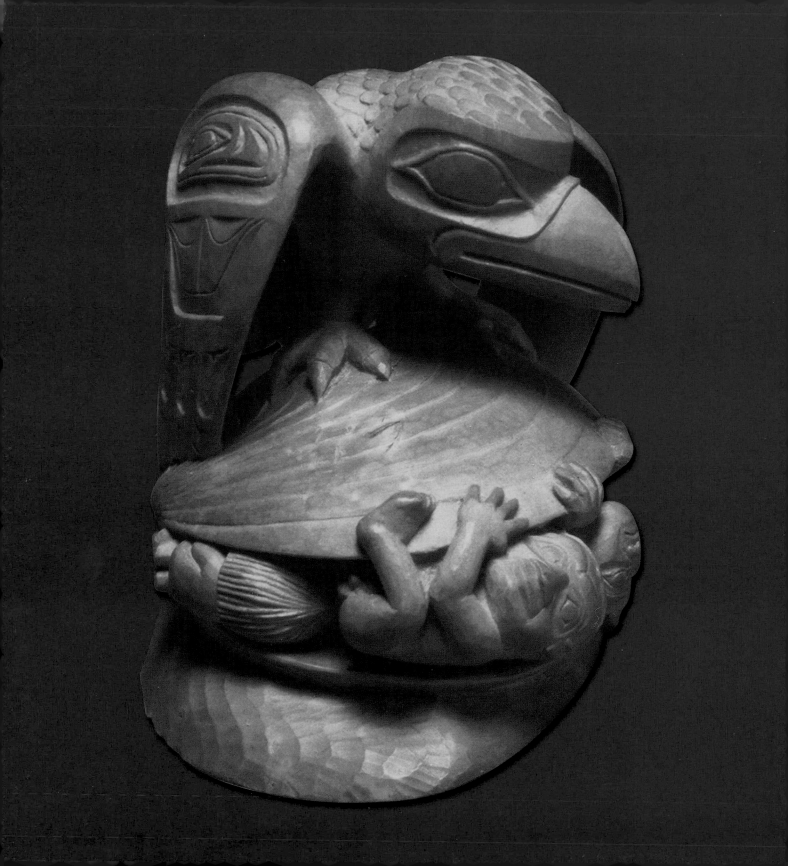

INTRODUCTION

On Seeing

LOIS HUEY-HECK

The first time it happened, everything changed. Ten years after my first stint at college, I was back at school – a so-called mature student in Fine Arts. Mike Young brought in an Ann Kipling drawing to show us. I'm not sure I'd ever seen anything like it and my first impression was not positive. But Mike obviously respected Ann's work and I respected Mike, so I decided to try really looking at the piece. As I recall, it was a large loose drawing – many tiny disjointed lines that could be mistaken for a page of doodles if you just glanced at it.

Luckily on that day I didn't just take a glance, form a negative judgment, and turn away. I stood – for what seemed a very long time – in front of a scratchy portrait of a woman. After some time had passed, the image began to shift and formed itself into a portrait of an Inuit man in his parka. Whoa! How did that happen? I kept staring at the drawing and, as miraculously as before, the face became that of a very young woman… a male youth… a child. I had never seen anything quite like this. It was almost like a hallucination, but without the quality of losing control. This shifting vision came from the art – but with my active participation.

My meager understanding of *what art is* got blown wide open that day. I had to acknowledge how ready I had been to judge art as either good or bad – and on what flimsy evidence I based my pronouncements. Ah yes, it was one of those humbling teaching moments. It gave me a deep appreciation for open-ended art – art that doesn't tell us everything (in the way the dreaded morality story tells us how things should be). More than awakening an appreciation of open-ended art, this experience opened me to the value of almost every style of art and manifestation of human creativity. It also changed the way I see. I came to appreciate how important time is when it comes to seeing.

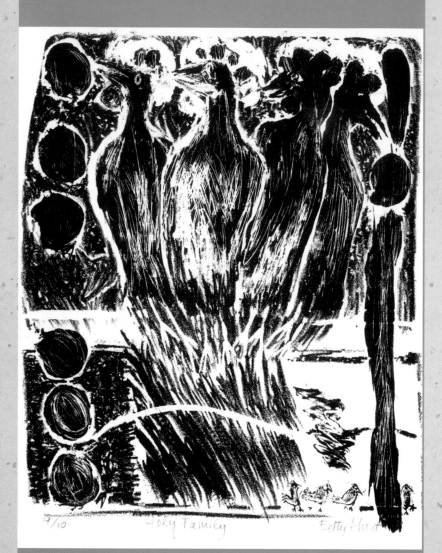

9/10 Holy Family Betty Dhont

Holy Family, 1988
BETTY DHONT
Lithograph; 24 x 30 cm

Holy Family *is at once
reverent and irreverent. This
family of Bantam chickens is
celebrated as being as good
and holy a part of creation as
the rest of us. The image also
protests the brand of religious
intolerance that "decrees"
whom and what is holy – and
what is not.*

The importance of taking time with art reminds me of hearing new music. Many times I've gotten a new recording and not liked it much the first time I heard it. Not always, but often, I have come to enjoy it after several hearings. Culturally, we move so fast now. We travel fast, work fast, make fast choices, eat fast – and often give only seconds to looking at a piece of art before assigning judgment and moving on. Acknowledging the fast pace of our lives today, Don Grayston1 says, "Anything that slows us down is a spiritual practice."

What I like/don't like, or what I want hanging in my living room, are no longer the only ways I assess the value of art. And while I still admire technical skill, I have little patience for a show of skill that has no soul. What I want from art now is depth. I want it, like conversation and like life itself, to go beyond the superficial. And, like good conversation and life itself, I want art that has the potential to transform.

When we take the time to really see a piece of art – we are affected in some way. Perhaps we become aware of something we were not conscious of before. Maybe we are moved to tears, which we may or may not understand. Yet again, we may experience strong emotion or a sense of connection. Any and all of these responses can and do happen, plus a myriad of others.

Here's a core belief that Jim and I hold. Something will happen to us when we see an image; even if we cannot articulate what that something is, we will be affected. Just because we can't put into words what we saw or felt or how we were transformed does not mean that nothing happened to us. This is one of the frustrations felt at times by art viewers and by artists. Visual art is another language and it doesn't always translate into words. As Picasso is purported to have once said, "If I could have told you what it means, I wouldn't have needed to paint it."

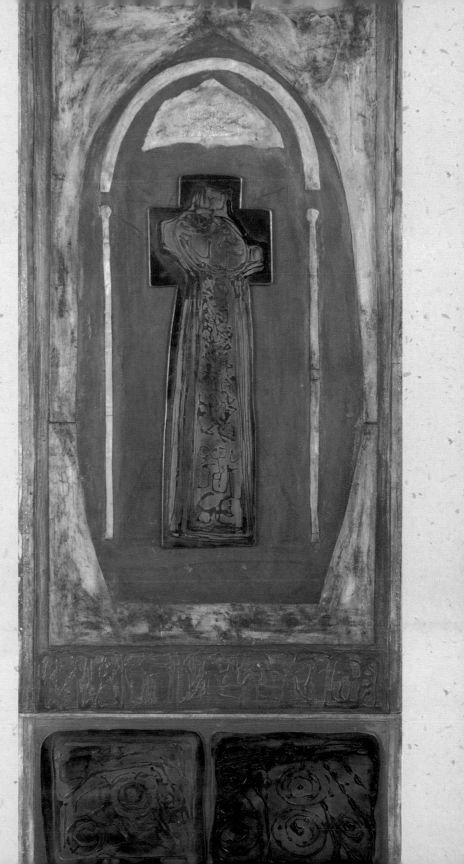

Portal (detail); 2005
MARY SMITH MCCULLOCH
Collagraph plates, 1 of 5 panels;
152 x 66 cm

The Portals have a presence that speaks of time and timelessness, past and present, and of gateways between the worlds. The language of moody colour and texture tell us as much about Celtic Spirituality as do the iconic Celtic Crosses themselves.

Unfortunately, we have placed such a high value on words that we feel inadequate if we can't put our experience into written or spoken language. When we feel inadequate we tend to shut down.

Can we hear the parallel here in our attempts to articulate spiritual experience? When it comes to spiritual experience, words are often woefully inadequate. For that matter, neither do images or any of the arts fully convey the Great Mystery. Taken with the other faculties available to us, however, engagement with visual art can teach, guide, and encourage us on our journey into deeper, more mature spirituality – which is at least part of the goal of the world's spiritual traditions. In *Drawing Down the Moon*, Margot Adler quotes Symmachus, from 16 centuries ago: "Not by one avenue alone can we arrive at so tremendous a secret."

It's important to understand that there is no formula for this deep looking. Neither the spiritual life nor the creative process will be reduced to a predictable recipe for success – though some would tell us otherwise. Even so, there are some practices that improve our chances, such as spending time, being open-minded, and staying fully present. On the book's website www.spiritualityseries.com, you will find art-based spiritual practices for each of the chapter themes.

When we open ourselves to the intrinsic value of art – in its vast array of styles and techniques – we open ourselves to being met by the Holy One who speaks in unexpected ways. May you be surprised.

There is terrific transformative power to be found in the practice of really looking – of opening ourselves to really seeing.

Green Man; 2005
RALPH MILTON
wood; 30 x 50 cm

This is a very personal green man – carved as a totem for its creator. This alternative model of masculinity is intrinsically bound to the earth, generativity and creativity – far more positive than the armored conquering knight on horseback. The green man's enduring power is due to creativity rather than destruction.

1
Art as a Thin Place

LOIS HUEY-HECK

Carl Jung used the image of two cones, apexes pointing towards each other, as a way of describing the relationship of spirit and matter. With one cone representing matter and the other spirit, the points of the cones indicate the way spirit and matter "meet and don't meet."

The symbol of the cross is sometimes understood as indicating a meeting place of spirit (represented by the vertical bar) and matter (the horizontal bar.) This makes the cross – a pre-Christian symbol – a fitting image of the divine becoming human and the human becoming divine.

Speak to Me; 1990
MAUREEN LISLE
Mixed media;
103.6 x 201.1 x 109.7 cm

I went on the castle tour for my son, Bryan, who had so wanted to make the trip to Scotland with me. Ever since he'd studied the U.K. in school, he'd wanted to visit. Since I couldn't manage to take him with me, he asked me to go to Loch Ness on his behalf. I tried, but the tour was canceled. Even though Edinburgh Castle was second choice, it was grand. The tour guide was funny and knowledgeable, the site and the stories were interesting, and the huge memorial at the top of the rock was awe-inspiring. The guide explained that the books in the memorial hall named every woman and man who'd lost their lives in military service for Scotland. We were asked to be silent in their memory.

After the castle tour, I got out my little booklet *A Walking Tour of Edinburgh* and started to read:

Leaving the castle we now start on the legendary route through the old town of Edinburgh…

My heart nearly stopped on reading the last sentence of the page:

On the wall near the top of Castlehill is a plaque which marks the spot where nearly 300 witches were put to death between 1479 and 1722.

The words hit hard.

There were no direction signs and I missed it on the first try. Turned out it was tucked behind some parking cones. If not for that one sentence in the guide book, I would have walked by, oblivious. Instead, my day, my trip to Scotland, and all my subsequent trips have been affected by what I found.

There it was – a small bronze relief mounted on the wall beneath a bronze plaque. The phrase *conspicuous by its absence* comes to mind. Reading the plaque I learned that the site had once been a fountain. It was now completely dry. Worse yet, the rectangular "pool" where a stream of water once flowed was filled with garbage. I stayed in front of the derelict "monument" a long time, transfixed. I was trying to take in

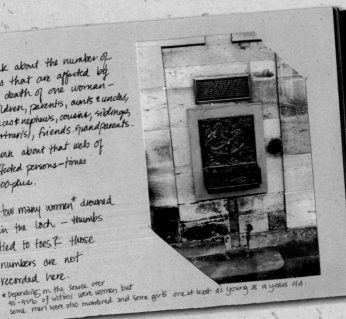

Think about the number of lives that are affected by the death of one woman— children, parents, aunts & uncles, nieces & nephews, cousins, siblings, partner(s), friends. grandparents.
Think about that web of affected persons—times 300-plus.

How many women* drowned in the loch — thumbs tied to toes? those numbers are not recorded here.

* Depending on the source over 90-95% of victims were women but some men were also murdered and some girls one at least as young as 9 years old.

May 1995 Edinburgh

the implications of the place through what I was reading and seeing. It was a lot to integrate – the incredible horror described almost off-handedly; the neglect of the place; and my intense, visceral reaction. There was layer on layer of "stuff" to process – the pomp and ceremony of the castle and war memorials overshadowing this tiny, neglected, half-hearted "memorial", with its spare acknowledgment of the barbaric torture and killing of the (mostly) women accused of being witches. It made me weep – it still does. Whatever may have been the intent of the designer, "John Duncan, R.S.A.," or whoever commissioned the fountain, this relatively small piece of art and its relegation to near invisibility has been working on my psyche, spirit, body, mind, and art-making for over ten years.

left: excerpt out of Lois' journal
LOIS HUEY-HECK

Witch Fountain, 1998
LOIS HUEY-HECK
Mixed media on paper.

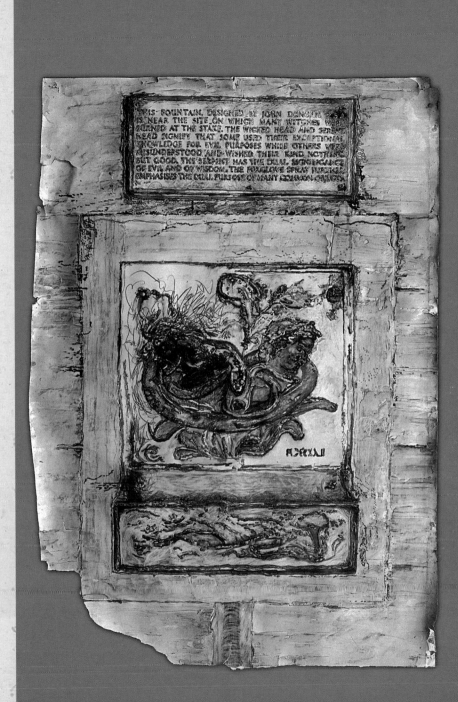

I'm still being shaped by this image, which tore away the grave-cloths of the centuries and made me feel the tragedy. It's not only for the people of history that I grieve, but also for the current tragedies – of scapegoating, prejudice, sexism, sadism, and greed. The experience was similar to the overwhelming sense of horror I'd felt years before, while visiting the Anne Frank house in Amsterdam (having read Anne's diary as a girl).

From the perspective of today, I understand these moments as "thin places" made accessible by the arts. Each encounter brought my "safe" world into contact with the reality of oppressed peoples – those tortured or martyred because of their race, gender, or religion. For some, this may seem to stretch the Celtic understanding of a "thin place" – a place where the veil between the worlds nearly disappears – but I understand this deep empathy, which can cross time and place, as only one of many ways we can experience connection between worlds. Having once felt this empathy, we must live differently. I experience that manner of awakening, and the place where it happens, to be a holy "place", a "thin place."

The concept of thin places first came to my attention when I learned about Iona, the sacred island off the west coast of Scotland, renowned as a thin place. Whether Iona became a thin place because it has been a place of pilgrimage, prayer, and just-action for so many centuries, or whether it became a pilgrimage site because it was first a thin place, I do not pretend to know. Either way, for countless pilgrims – myself included – the world of spirit feels very close on Iona. For indigenous peoples around the world – people of the land, like the Celts – there are many thin places, many sacred places, on the earth. Whether or not we notice is another matter!

Thin places are where we become aware of the meeting of spirit and matter. As Carl Jung said, "Spirit and matter meet and don't meet."

As the story above illustrates, *thin places* can be moments in time, when the boundaries break down and we are aware of the All. Such moments can occur during meaningful ritual, deep conversation (like soul-friend conversations), and while making love. The saints and sages, prophets and mystics, live in that place where spirit and matter meet and don't meet. Although it's not exclusive to them alone, art viewers and art makers are very often visitors to that place, as well. Let's turn to some examples of art that have evoked a sense of the sacred in Jim and me.

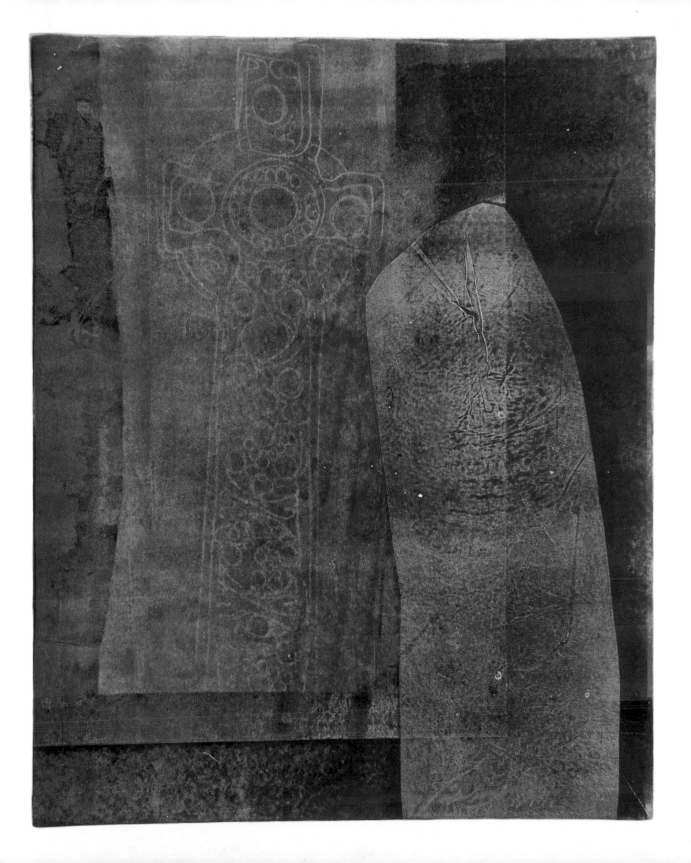

ART AND ARTISTS
Jim Kalnin

*Let the beauty
we love
be what we do.
There are
hundreds of ways
to kneel and kiss
the ground.*
Rumi

Oftentimes, art brings us to a spiritual point of view, even when it was not intended to do so. We can find inspirational truths in everything, from the tormented paintings of Vincent van Gogh to the banal lyrics of a popular song. We can also, of course, find thin places in contemporary art where they were intended. I have found many thin places of both varieties – intended and unintended – on my convoluted journey, including some refreshing ones I came upon while I was living in Thailand, in 1984. I was lucky enough to discover a whole movement, which at that time helped bring a spiritual viewpoint back into my life. I was introduced to the work of a recent wave of Thai artists who had forsaken international, modern art influences, to return to their cultural roots. Most of them were, and are, practicing Buddhists and their work often refers back to the historical tradition of Thai mural painters. They live basically secular lives and use modern art materials and techniques. They are also more individualistic and inventive than their monastic predecessors, and display great differences, even amongst themselves.

It took me several days of wandering in a number of different directions in Bangkok (mostly on hot, crowded buses, or in the open-air motorized carts called Tuktuks) to find the work of these artists. Not knowing the language and not being able to read the street maps turned my quest into a series of misadventures. Some of my false starts were interesting, however. I toured an empty, off-semester art school, graciously guided by the only people present, the school's two janitors. Their hospitality and humor, my Thai-English dictionary, and a lot of pantomiming made it a rewarding and entertaining afternoon, though it didn't bring me any closer to these new Buddhist paintings.

However, my determination to find them eventually paid off. Exhausted yet elated, I finally entered a small, clean, and, thankfully, air-conditioned gallery. The recent paintings and drawings of six Thai artists hung there, and I wasn't disappointed. I found them all interesting, though two artists seemed to have a clearer vision as well as a better command of their media.

Surasit Saokong's paintings are the most precisely detailed and representational of these works, and a perfect antidote to the city outside. Many of his paintings share the same theme and the same title – *Serenity*. They include many views of interiors and exteriors of temples (called Wats) and monasteries, as well as images of meditating Buddhist monks, and panoramic views of the Thai landscape. Standing in front of some of them for long periods of time, I had no doubt that Saokong himself lived in serenity; as I stood there, the many thoughts in my head dissolved and I became serene as well. Here was a thin place indeed. I later searched out as many of his paintings as I could find, all of which had a similar effect on me, bringing me to a place of inner peace and calm acceptance. This effect would last about as long as it took me to walk back out into the noise, chaos, and pollution of Bangkok.

Serenity; 1981
SURASIT SAOKONG
Oil on canvas; 105 x 130 cm

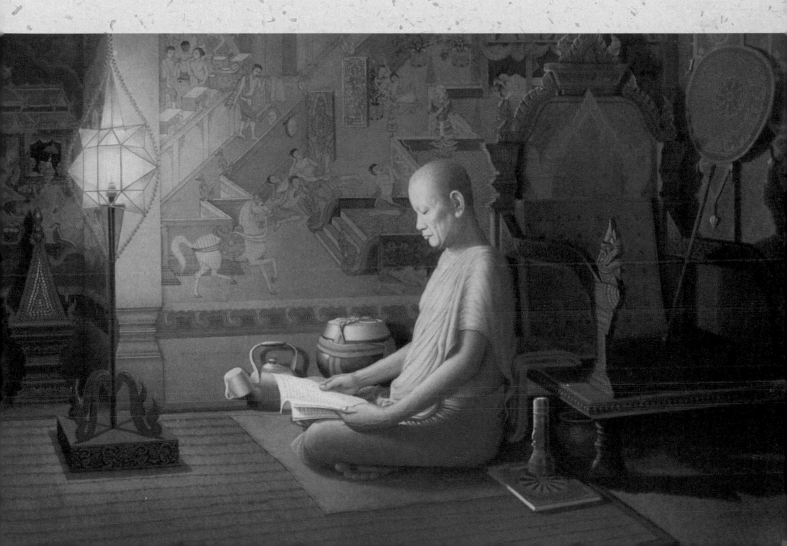

Regeneration #30; 1998
JIM KALNIN
Mixed media on paper; 8 x 6 cm

Other members of this group express Buddhist ideals in different ways. Some of the symbols elude me, no doubt because of my almost complete ignorance of Buddhism. Still, on a natural, human level, they speak to me.

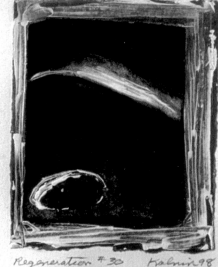

Serenity; 1980
SURASIT SAOKONG
Oil on canvas; 102 x 131 cm

I had no difficulty with the symbolism used by Pratuang Emjaroen, whose work covers a much wider range of styles and topics than does Surasit Saokong's. As Surasit portrays serenity, Pratuang paints anything but that. Everything in his pictures is in motion. Everything pulsates with light. Whether the work portrays a rice field, a rice farmer, or the Buddha fasting, the force of life is always evident. Physical and spiritual nourishment are common themes in much of his work, as is his bond with nature, though the piece that I found most compelling showed this in a more abstract way. Perhaps this is its success; the work is more open to personal interpretation. It is open-ended. The painting, which is actually called *Force of Life*, has the simple compositional device of a circle within a square, similar to the ancient Buddhist brush and ink paintings which symbolized the unity of all life. The circle is a simple drawing of a piece of fruit, and is filled with small shapes that could be seeds or grains of rice, or other natural objects. They, too, are glowing and appear to be in constant motion. Rather than identifying them as particular known objects, I tend to view them as abstract forms that symbolize all of life. They have the potential to be anything. To Buddhists, *Om* is the sound of the universe. Perhaps this painting can be seen as a visual representation of that sound.

Force of Life; 1974
PRATUANG EMJAROEN
Oil on canvas; 140 x 140 cm

Broadway; 1935-1936
MARK TOBEY
Tempera on Masonite; 66 x 48.9 cm

Like Pratuang Emjaroen, many Western artists use non-objective art as a means of *writing* a spiritual language. Although Mark Tobey grew up with a different religion and in a different culture, his abstract expressionist paintings have much in common with the work of these Buddhists. A follower of the Baha'i religion who spent time in China and Japan learning to paint with ink and brush, he developed what came to be known as his *white writing* paintings. His early experiments with this approach included such works as *Broadway*, which is loosely based on his impressions of New York. (Later, his *white writing* paintings became completely abstracted.) The underpainting, which usually consisted of layers of transparent colors, would serve as a ground for his spontaneous linear marks in white or light colors, which were also built up in layers. The end result might look vaguely like the subject matter, such as New York City's famous Broadway; but through the rhythmic, repetitive lines, tones, and shapes, Tobey also painted the movement, pulse, and energy of the city. Other works were derived from the night sky, aurora borealis, changing seasons, and other natural effects.

Tobey created representations of the rhythms of life during the first half of the 20th century, much like Pratuang Emjaroen has done since then. Influenced by his religious beliefs, Tobey worked to decentralize his images so that all parts of a painting were of equal value. He saw this act of *writing* a painting as a kind of performance, which allowed him to express his love of big cities such as New York. In an interview in Katherine Kuh's book *The Artist's Voice*, he stated,

At last I found a technical approach which enabled me to capture what specially interested me in the city — its lights — threading traffic — the river of humanity chartered and flowing through and around its self-imposed limitations, not unlike chlorophyll flowing through the canals of a leaf.

Perhaps Tobey's abstract paintings are best seen the same way we look at high, arched church windows. Both use the colors, forms, lines, and shapes of visual *language* to describe the indescribable.

Adriana Diaz is another artist working with the idea of a spiritual language. Her studies come from a different source than Emjaroen's *Force of Life* or Tobey's *Broadway*. Both of these artists start by referencing actual objects, while Diaz's painting *Tremor* uses the gospel of John for its inspiration. About this work she writes,

Tremor *refers to the physical vibration and possible emotional elements registered in the body when language is voiced or received. The gospel of John, then, is interpreted as a celebration of the human potential to voice and create patterned language with which to communicate and praise God. Each mark is a symbol of the primal impulse to, and the act of, self-expression. Collected marks, then, are equivalent to a symphony made up of collected individual notes.*[1]

Looking from one to another of these three artists' paintings is an interesting exercise. Their cultural backgrounds differ, as do their sources and the marks they make. But, through their attempts at spiritual language, they all speak of the Great Mystery; and, through their rhythm and motion, show us a possible vision of that Great Mystery, on a molecular level.

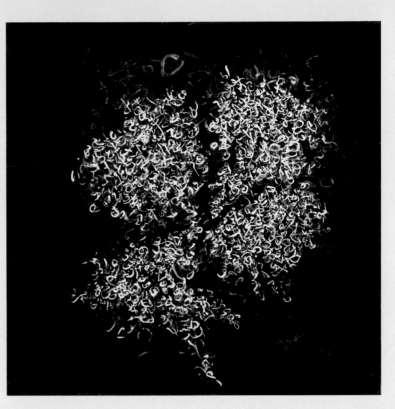

Tremor
ADRIANA DIAZ

One recent movement that we don't often think of in terms of spiritual art is the anarchistic realm of installations. Joseph Beuys, one of the most influential artists of the last half-century, was one of the first to do serious work in this medium. For his part of an exhibit by emerging artists in a rundown part of West Berlin, he cleaned up all the garbage and debris on the street outside the exhibition and displayed it inside as his art, making a statement about taking responsibility for our environment. Beuys was an environmentalist, a political activist, and a founding member of the German Green Party. He also instigated the planting of 7,000 oak trees in Kassel, Germany, in an attempt to inspire other cities to follow suit. Since Beuys' early efforts, countless others have made installations of every conceivable description in every kind of interior and exterior space.

American artist Ann Hamilton has become internationally known and respected for her epic process-oriented installations. They often involve massive amounts of material that completely reform the gallery space and offer viewers new perspectives on life. Most of her installations are disassembled after the exhibitions and the materials recycled. The work lives on only in documented forms, such as photographs, videos, sketches, or written descriptions. These artists also offer a refreshing change to *art as commodity*. Although many installation artists do have spiritual backgrounds, there is not yet a tradition of this kind of work in established religions.

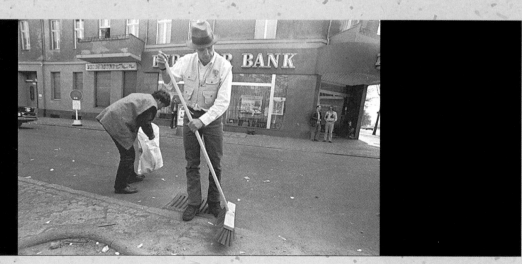

Joseph Beuys,
Karl-Marx-Platz, Berlin, 01 Mai 1972
– *Sweeping Up; 1972*
JÜRGEN MÜLLER-SCHNECK
Photograph

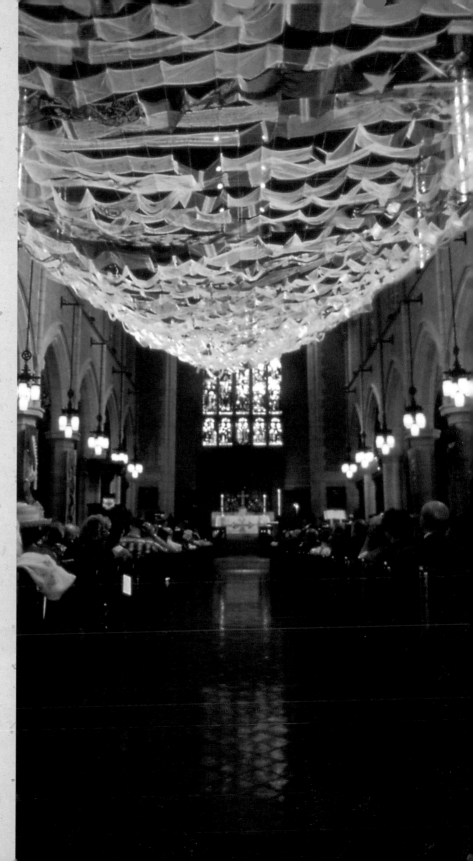

Nancy Chinn is one artist who has brought installation art into the church. In response to her own dissatisfaction with dull church interiors and equally dull services, she started designing large paper banners of angels. Encouraged by her pastors and the congregation, many of whom eagerly volunteered as helpers, she evolved a wide range of mounted and hung religious imagery that complemented the various themes of worship. Using paper, fabric, paint, and available lighting, she and her army of assistants now created banners; mobiles; and great, sweeping arches of shimmering, colored light that took their religious gatherings to new heights. Within a few years, she found herself teaching this form of installation art to others. She also took on many commissions from other churches and began writing books about her experiences.

Rather than hide the church interiors, these installations work to highlight and complement them, maximizing the effects of high, vaulted ceilings and colorful stained-glass windows.

Prayer Canopy; 1993
NANCY CHINN
installation

Tibetan Prayer Flags
MICHEL DECLEER

Nancy Chinn's bringing of this contemporary art form into the church can be seen, in a way, as the completion of a circle. Some of the roots of installation art reach back in time to early spiritual practices in a number of different cultures. Tibetan prayer flags, which aid Buddhists in their meditations and prayers, can be considered one of these roots. Draped on buildings, hung on wires and tree branches, assembled in cities and on windswept plains, they call out to the heavens with earthly concerns. They have been part of Buddhism for millennia, although their use has increased tremendously in recent times. This is due to the fact that most Tibetan Buddhists now live in many other parts of the world, as refugees from the Chinese government's occupation and control of their country and its major religion.

Another cultural phenomenon that preceded installation art occurred across the Pacific Ocean in western North America. For the peoples of the Plains Nations – now known as the Sioux, the Cheyenne, and the Blackfoot, amongst others – the medicine wheel has both scientific and spiritual roots. Much like Stonehenge and other similar constructions, these symbol-laden circular arrangements of stones, usually found on a high point of land, were aligned with the stars, moon, and sun. They were used as observation sites and also in ceremonies that expressed reverence and gratitude to the earth mother. Some of the few remaining sites are still in use today.

These are some of the endless ways that art can take us to the thin places between the worlds – the places where the worlds of spirit and matter co-mingle. There are other ways, of course, and as the human race grows and evolves many more will no doubt be created. Art is always a sign of the times, a mirror of its own culture. New technologies find their way into the world of art and into our spiritual beliefs. We will look at some examples of this in subsequent chapters.

Which art becomes a thin place, and how this happens, is different for each of us. We all know what we like. Through this book, however, Lois and I encourage you to take the time to look at a wide range of possibilities. Suspending judgment and overcoming the need to have answers to everything can indeed open some doors behind which lie great rewards. Learning to look at art as a form of prayer or meditation leads us to new levels of understanding, and makes any spiritual journey that much richer and more rewarding.

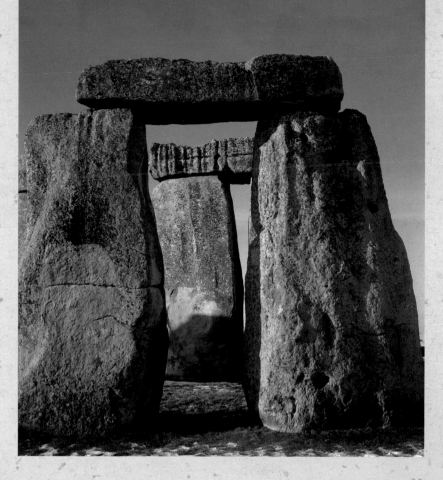

A Winterview of a Sarsen and Trilithon at Stonehenge
EDWARD PIPER
Photography

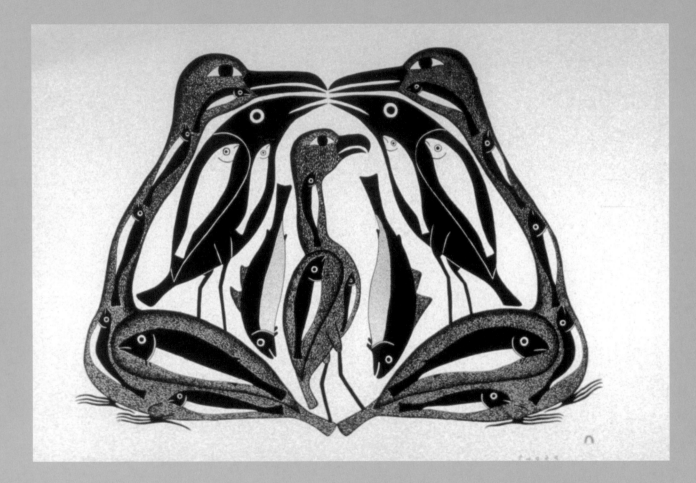

2 Art as Sacerdos

Jim Kalnin

In 1975, I spent nine months in the Inuit community of Cape Dorset, on Baffin Island, in the Canadian arctic. I was working there as director of the Sikusilarmiut Film Workshop. The project was set up by the National Film Board of Canada to help Inuit artists produce animation films. Living in a completely different culture and landscape for the first time was constantly challenging and rewarding. It was also a great privilege.

I arrived in Cape Dorset in December, when everything was frozen. Many months later it was spring, and everything was still frozen. Soon after spring arrived, it left, and then it was summer, and everything started to thaw. One of the locals described the difference between the seasons by saying, "It's cold in winter and it's cold in summer. The only difference is in summer the cold won't kill you."

Sacerdos is the Latin word for priest, literally translated as "giver of the sacred."[1] Artists function in this capacity in various ways. They look at the mundane and the commonplace, and see it as beautiful and meaningful. They remind us of the rhythms and dance of life. They see the empty places as being full of light and spirit, and remind us that life is everywhere, and that we are never alone.

Arctic Assembly; 1996
KENOJUAK ASHEVAK
Lithograph

Producing animation films in an oil-heated trailer stuck on a rock in the tundra, with no technical support in sight, was an absurd idea. The National Film Board thought it was a good one, though, and looking back now at the surprising and powerful little films made there, I agree with them. And, even then, the technical and cultural difficulties we encountered were eclipsed by daily wonders and growing friendships. Laughter became an indispensable tool and a way of life. The dark, interminable winter was filled to the brim with daily dramas and wonderful discoveries. Evenings of dancing at the community hall and visiting for tea kept the raging winter at bay. When summer finally arrived, however, everything changed. The days grew

longer, then the sun didn't set, and people stayed up all night. Families started going out on the land to summer camps. For traditionally nomadic people, this pull was too strong to keep even our eager filmmakers in the studio and our winter's film production skidded to a halt. Before long, I was bundled into a boatload of friends and we journeyed along the Baffin Island coast to a distant fishing camp.

Our voyage in the 30-foot freight canoe through a dead calm arctic sea was hauntingly beautiful. The low, Precambrian land mass seemed barely able to keep the sea and the sky apart. The impending weather, the ever-present cold, and the light itself seemed capable of dissolving the land and everything on it. We were dressed warmly enough

in the canoe, but something was making me shiver. Nature had never given me such feelings of insubstantiality before. Even though I was in a boat full of people, I felt alone and found myself searching the distant coastline for a glimpse of the camp. Finally, I saw what looked like two people standing on the ridge watching us, and my heart swelled. I pointed and made a high pitched and inarticulate sound. Kananganak looked up at me from the stern, where he ran the outboard motor and smiled. "Inukshuk," was all he said. Then I heard a few sighs and realized that the mood in the boat had lightened considerably. Others had seen the two figures as well. Although they knew what they were, they also seemed relieved to see the Inukshuk standing there. Everyone was smiling now;

we had been welcomed to camp. We landed and were greeted by the living – family and friends who offered us hot tea and bannock, as well as smiles and hugs.

Art functions to fill the void and in doing so it heals us. The Inuit who piled up stones to mark the camp were also filling the void, thus acting as sacerdos. I felt a spiritual presence in the two stone figures, and a number of my Inuit friends told me they did too. So did their ancestors. To long-ago hunters, alone on the land for days or gliding in their kayaks, Inukshuks were signposts on their travels. They were also a sign of human presence, and a sign of the sacred.

opposite and left:
arctic sceneries
JIM KALNIN
Photography

below:
Inukshuk
Photography

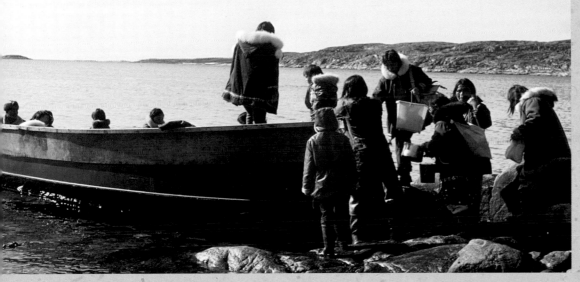

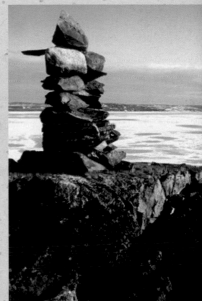

ART AND ARTISTS

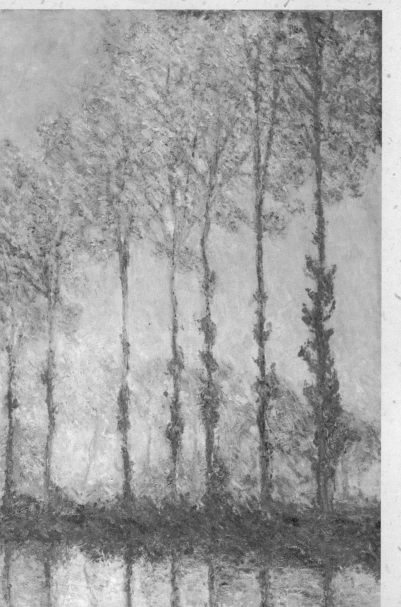

Paintings, sculptures, and murals tell the stories behind every religion. The Buddhist Wats in Thailand gave me some real insights into Thai life, as well as into the Buddhist religion itself. Murals depicting the Buddha and narratives of the events of his life showed me how intertwined Buddhism is with the rest of Thai culture. Art does more than introduce and explain, however. It can also promote states of spiritual awareness, as do prayers, Zen koans, labyrinths, and mandalas.

It has been the responsibility of artists within these traditions to aid others in their spiritual awakening. Artists working outside organized religions have also contributed to human spiritual growth, especially in the modern era. Vincent van Gogh and many of his contemporaries fall into this category. Although they may not have thought of themselves or of their work as being religious, they had a reverence for life. Their innate understanding of nature still speaks to us through their art in ways usually defined as *spiritual*. That's how I respond when I look at van Gogh's paintings of sunflowers, furniture, or starry nights. The rhythm and flow of his brush strokes from one form to another suggest a sense of awe and joy at creation; the things he paints seem to be bursting with life. It seems as if I'm looking at the very molecules of matter, or at the spirit behind the form. The physicist David Bohm says that *matter is frozen light*.[2]

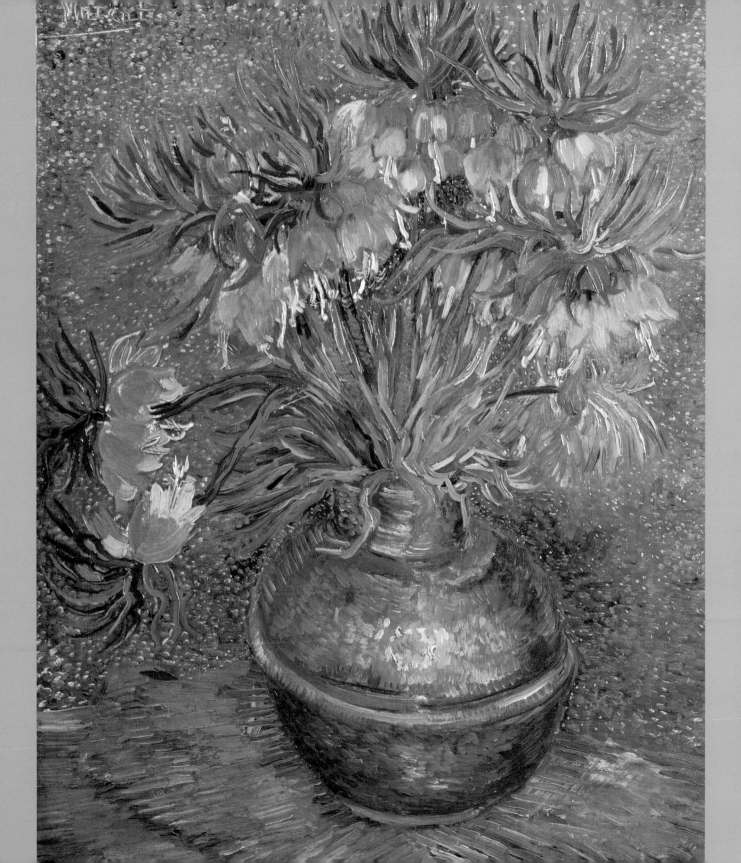

Since van Gogh's time, countless artists have been searching for the spirit behind the form. The art they produced expressed an awareness of the interconnectedness of all things. Perhaps spiritual expressions like theirs occur less frequently in the post-modern art world, though there are still a few internationally recognized artists whose work is spiritually driven. For example, there seems to be a growing connection between Buddhist thought and contemporary sculptors and installation artists. In painting as well, there is a continuing history of equating spirituality with nature. Loose and spontaneous approaches to depicting subject matter have become synonymous with spiritual expression because they tend to be open-ended.

It has been said that much of this work has the power to transport the viewer, which is also a function of sacerdos. Many have written about standing in front of a particular painting and being moved to tears by its beauty, or feeling the ground shift, or even hearing angels. Others have reported being transfixed and feeling as if they could walk right into the landscape before them.

I had stood in front of a lot of paintings only to feel disappointed. None of these things had happened to me. At least, not until I saw the Paterson Ewen exhibition "Phenomena," at the Vancouver Art Gallery, in 1988. These were large paintings with barely recognizable forms, no details, and a lot of expression. They were uniquely made. Using wood gouges, he carved the images into sheets of plywood and painted over them with acrylic washes. He sometimes added string or metal. This technique was an accidental discovery. Ewen originally made his images as large woodblock prints, but found the blocks themselves more interesting than the prints. Most of these epic works were of subjects such as typhoons, ice floes, sunspots, or comets, all roughly depicted. I wandered through the exhibition, marveling at the artist's ingenuity and economy; how he managed to say so much with so few marks, how he incited my imagination. I found whimsy and irony in some of his crude visualizations. I visited each piece several times and returned to my favorite few yet again.

Finally, I was standing very still in front of a large painting titled *Clouds Over Water*. My mind was as still as my body, my attention focused on the small glowing cloud (a piece of painted sheet metal) that hung in the golden sky. The painting seemed to grow not larger, but more profound, more intense. I felt I could walk right into it. This was a spiritual awakening of sorts – a new and growing aspect of my life. Unwittingly, Paterson Ewen had become a sacerdos – a giver of the sacred – for me.

The Western art tradition of spiritually focused landscape painting, of which Paterson Ewen would be an unintentional and probably reluctant contributing member, goes back far before his time. It really started with the Romantics in 18th-century Europe and evolved from their idyllic views of nature. After several subsequent art revolutions, it now includes a wide and still growing range of styles and sensibilities. Almost everyone in the Western world has watched golden rays of sunlight breaking through dark clouds and has associated that light with heaven. We see other aspects of the world as spiritual metaphors as well. Lofty mountains are enduring and uplifting, dark forests symbolize mystery, flowing rivers and flowering trees represent the source of all life. These are just a few of the parallels drawn by artists in many cultures, and especially by those who live where wilderness is a large part of life.

Paterson Ewen's predecessors purposefully explored these metaphors in their work, from different points of view. Some rendered trees and mountains as minimal, essential forms in order to present the essence of life. These artists managed to create a powerful sense of presence in the way they painted.

Georgia O'Keeffe's paintings of flowers and bleached bones, and Emily Carr's dark forests, are good examples of this. Carr's dark and lyrical forests are alive with spirit. They fill me with the same feelings of reverence I get from walking in a real west coast rain forest, like the ones that inspired her. O'Keeffe's minimalist paintings of bleached bones and cactus flowers bring a similar sense of the awe of walking in a southwest desert, as well as an understanding of the interconnectedness of all things.

Forest, British Columbia; 1991–1932
EMILY CARR
Oil on canvas; 129.5 x 86.4 cm

Lawren Harris, a contemporary of Carr's, also painted the landscape in simplified and stylized forms that could inspire a sense of spirit or grace. His austere paintings of icebergs, mountaintops, or bare rock hills are full of spirit and life. Almost all religions incorporate the *Tree of Life* as a conduit between the physical plane of existence and the source of all life. Harris' painting *North Shore, Lake Superior* continues this tradition in a surprising way by using as his subject a tree stump.

North Shore, Lake Superior; 1926
LAWREN S. HARRIS
Oil on canvas; 101.6 x 127 cm

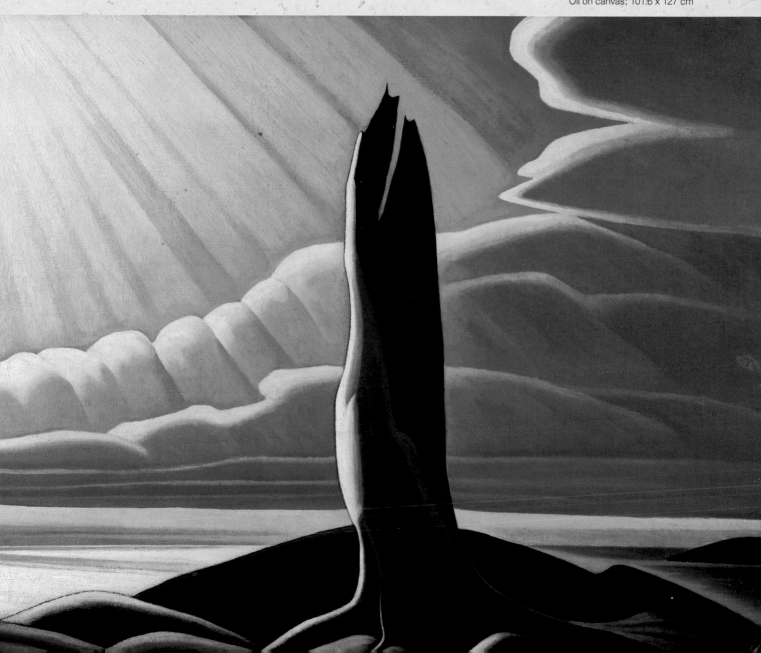

Others used more painterly and expressive styles in their landscapes. Charles Burchfield's *Orion in December* renders the details of forest and night sky into a cathedral-like array of simplified shapes and colors. He gives us the impression of heaven and earth in total unity. His fluid lines and expressive brushwork allow the image to pulsate and glow. The rhythmic use of thick, dark lines contrasts the lighter areas so they contribute to the dark forest's inner glow.

Orion in December; 1959
CHARLES BURCHFIELD
Watercolor and pencil on paper;
101.2 x 83.4 cm

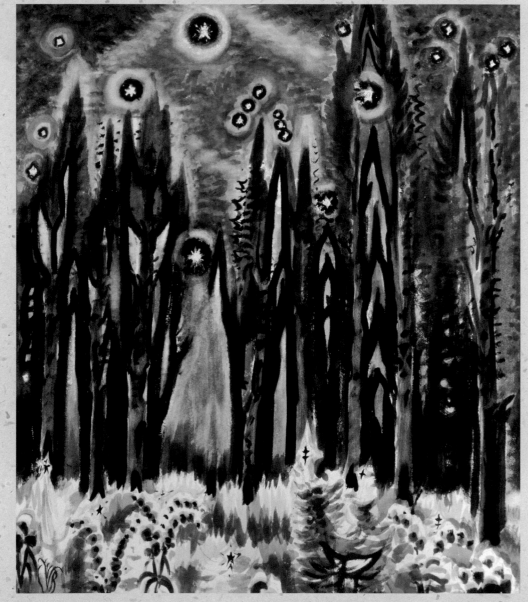

Art evolved through a number of concepts until some of it became completely non-objective or abstract. Spiritual representation survived this transition very well. Many artists found it easier to express what lay beyond the material world by eliminating recognizable objects from their work. Mark Tobey, presented in Chapter 1, was one of the first to make this a major theme in his art. In his action paintings, Jackson Pollock continued the all-over approach that Tobey initiated. Pollock attempted to remove control over the work in order to allow the painting to be made through him, rather than by him. Morris Graves, a contemporary of these two artists, also used massed lines and spontaneous drawing in his work to express the spirit behind the form. Graves, however, still relied on recognizable objects in most of his work. His drawings and paintings of birds and chalices, and his rhythmic, linear abstracted landscapes still carry on the tradition of "giving the sacred." Graves accomplished this with symbolism as well as with expressive lines and marks. Birds and minnows have spiritual meaning in his evocative drawings and paintings. In *Bird Singing in the Moonlight*, we can easily see our own selves yearning for the light. In this painting, the lines are as important as the bird and the moon, as they give us a sense of the interconnection of all things. When I spend time with this highly romantic painting, I feel that the bird and the ground below it are made of the moonlight, and I can almost hear the bird sing. If Graves had painted this with photographic detail, the effect would likely have been lost.

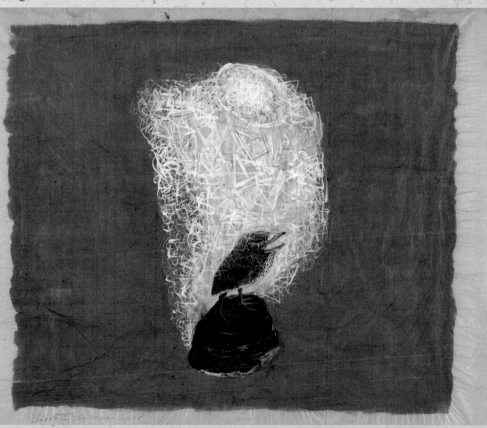

*Bird Singing in the Moonlight;
1938-1939*
MORRIS GRAVES
Tempera and watercolor on
mulberry paper; 68 x 76.5 cm

Another modernist painter who explored spirituality in an individual way was Mark Rothko. Completely non-objective, soft-focus color field paintings like his can be difficult to understand for those without an art background This is art that really needs to be experienced first-hand, in a quiet and well-lit museum or gallery. It requires time and patience. The patience we need is actually with ourselves; if we look at this work and conclude that we *don't get it*, our impulse is to just walk away. But if we stay we will eventually notice that something has shifted. We may notice things in the art we hadn't seen before; the painting appears to be glowing. It may seem that we are looking not at paint, but at the essence of life itself… the great mystery. This takes time, and practice. We need to move beyond our initial judgment and thoughts. Like any other prayer or meditation, it only works when our minds are still. What I experience in front of a Rothko painting is quieter and more contemplative than the dramatic effect of Paterson Ewen's work, but it is equally uplifting. Having no recognizable objects to look at, I am free to respond in much the same way I would to classical or jazz music. This is also a spiritual response.

Quite early in the development of photography, artists such as Ansel Adams, Edward Weston, and Minor White used the medium to explore the essence of physical form and its ability to act as sacerdos. Their work, especially that of Minor White, could bring about the same feelings of reverence as did the work of the painters. White, a deeply religious person, made a pilgrimage of his daily life and work. His intention was to take photographs that were spiritually inspiring to him. His hope was that his images would evoke the same response in others.

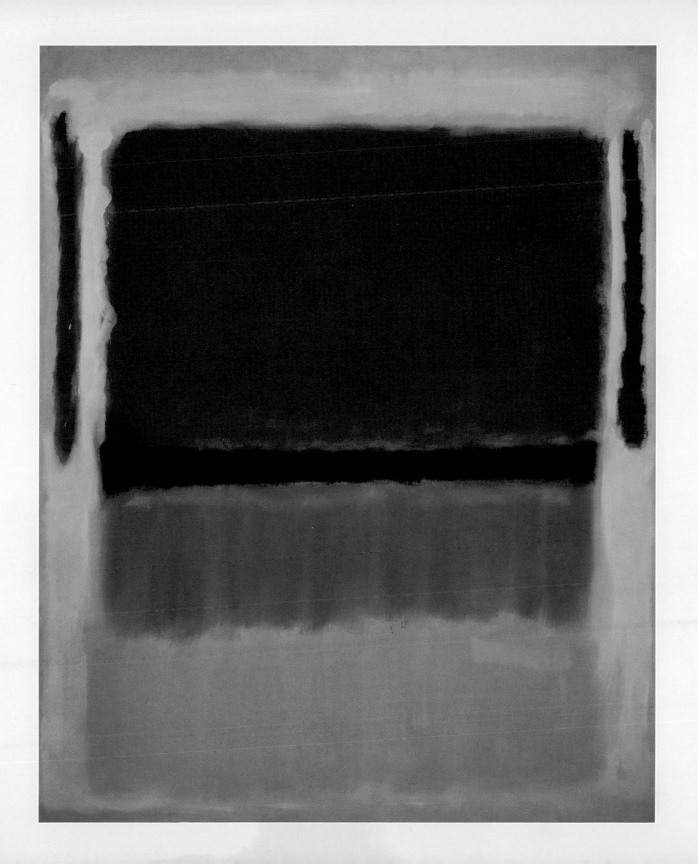

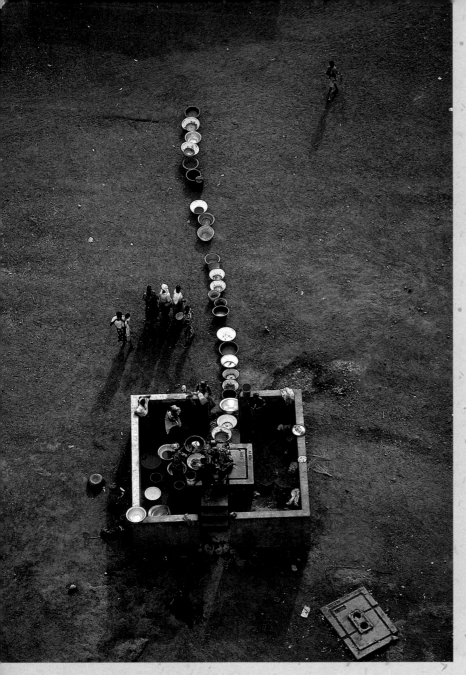

At the Well
YANN ARTHUS-BERTRAND
Photography

opposite:
Cars in the Cathedral, 1986
SCOTT MUTTER
Photography

Photography has become a more widely used and accepted art form since the work of these three practitioners. Cameras have evolved into a more sophisticated and versatile tool, and other recent technological achievements are also available to photographers. Wall-sized, high quality photographs are now common. We have ready access to close-up images of the nuclei of cells and of the moons of Jupiter. French photographer Yann Arthus-Bertrand takes his cameras into aircraft to give us another perspective on life. His aerial photographs, such as *At the Well*, show a poignant view of our connection to and dependence upon the earth.

For others, computer technology has opened new doors. Scott Mutter uses digital technology to superimpose or otherwise alter his photos to create new visions of reality. One of his main interests is in giving new life to spiritual teachings. He says,

The visual symbols by which we understand spiritual or non-material thoughts and truths no longer function. They've lost their interpretable and essential meanings.

Scott's photomontage entitled *Art Is No Idle Thing* superimposes a busy city street in the aisle of a cathedral. It revisits the idea of God being omnipresent, or of joy being where you find it. The abruptness of the image also prompts us to think beyond stereotypes. As sacerdos, he opens a door for us, inviting all to think outside the boxes our culture has built.

47

At its root, creativity is not about success or failure. It's a spiritual practice. It's mystery.

CLARRISSA PINKOLA ESTES

Video artists also make their spiritual contributions and Bill Viola has undoubtedly done more in this area than anyone else. A prolific artist and a practicing Buddhist, he makes images that help us push through the veil between the worlds. Taking the time to view his work can be an enlightening experience. For me, one of the most profound visual events he has created is his 1996 installation *The Crossing*. Two separate videos are simultaneously projected onto opposite sides of a two-sided screen. On one side, a man walks towards the camera from far off in a dark and empty space. When he almost fills the picture frame, he stops, and a trickle of water falls on him from above. The trickle then becomes a torrent, which engulfs him. The sound of falling water fills our ears. When the water stops, the man has disappeared. Meanwhile, on the other side of the screen, the same man is walking forward to stand and be engulfed from the bottom by flames. When the flames die out, he is once again gone. This video speaks of the transience of physical life more clearly than any art I have seen. Watching the images cycle continuously can remind us that life is also infinite.

For Viola, video technology is the perfect medium for making art that focuses on spirit as much as on form. In an interview in the November 2004 issue of *Shambhala Sun* magazine, he states,

We've been talking about the living spark that is in all people and all things they create, and video speaks in the language of sparks. Its image is not a fixed imprint on a piece of paper or chemical residue on a physical strip of celluloid, but a living, vibrating pattern of electrical energy.

While I agree with Viola about the living spark of life being easier to express in the medium of video than, say, bronze sculpture, I find traces of the essence of life in art of all media and disciplines. That is part of the power and attraction of art.

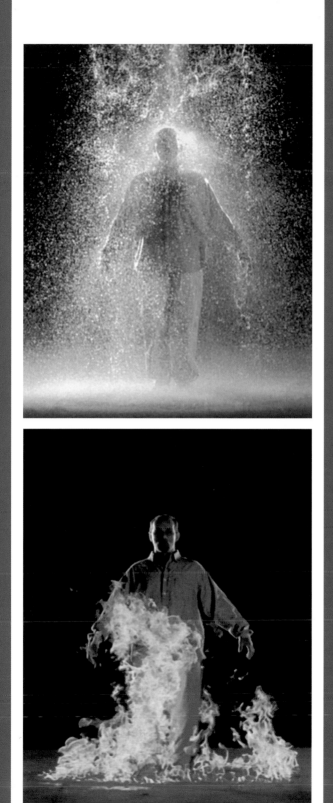

The Crossing, 1996
BILL VIOLA
Video/sound installation

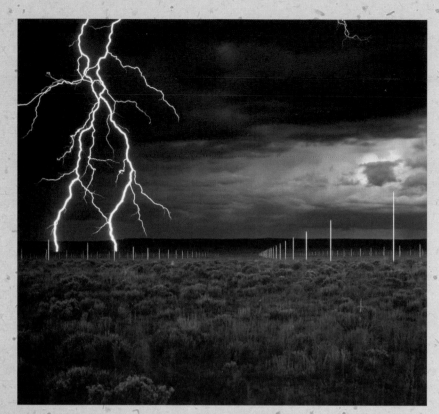

Epic land art projects – such as Robert Smithson's *Spiral Jetty*, built in 1970 in Great Salt Lake, Utah; or Walter de Maria's *Lightning Field*, in southwestern New Mexico – are examples of art in dialogue with the natural world. *Spiral Jetty* coils out into the shallow waters of the lake, 15 feet wide and 1500 feet long, reminding us somewhat of the mysterious earth mounds found in a number of locations. *Lightning Field* is installed on a high desert plain that is prone to electrical storms in the summer months. It consists of 400 stainless steel poles, each two inches in diameter and approximately 20 feet tall, spaced 220 feet apart in a one-mile by one-kilometer grid. Next to this lightning-attracting installation is a cabin, which can be rented for overnight visits. Other artists work in nature in a less dramatic and more sensitive manner. Andy Goldsworthy has roamed the earth, from his home in Scotland to Japan to the North Pole, making what he calls, yes, *collaborations with nature*. A broken tree, ice on a pond, colored pebbles on a beach – any and all of these inspire him to add his sense of order to that of nature. His works are often simple, always ephemeral, and quite astounding. Works such as his deepen my connection to the earth and in this I find inner peace.

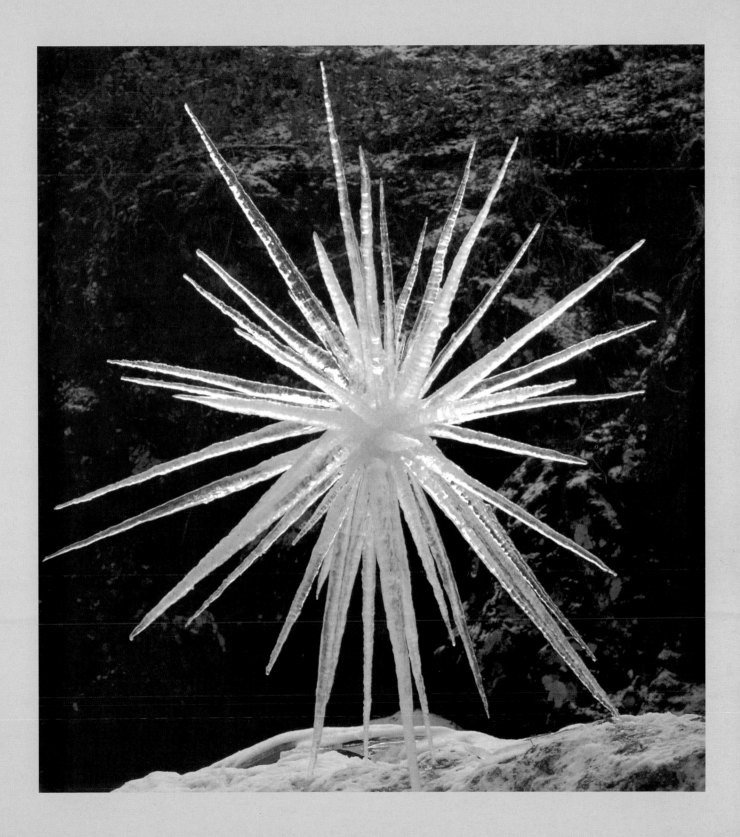

Touching North; 1989
ANDY GOLDSWORTHY
North Pole installation

The clay floor becomes an integral part of the building. I wanted it to be placed at or just below the surface of the existing floor so that it feels as is it has been revealed as something that existed before the building. The city, like the countryside, has been laid down in time over layers – archeological, botanical, geological… of which the clay floor is both evidence and reminder. There is a difference between a work that is made to the edges of the room and one that retains a border. One is an object and the other is the floor and is saying, "this is clay, this building is earth."

There is a meditative quality to many of Goldsworthy's small, ephemeral constructions that can awaken a sense of reverence in the natural world.

Anish Kapoor is a sculptor whom Germano Celant once described as sacerdos. This is evident in Kapoor's early work, such as the installation *1000 Names*. These simple forms, rubbed with pigment in primary colors, protrude from the gallery walls and floors. They are purposefully like nothing we recognize, yet somehow there is something familiar about them. Because of this, they serve as bridges to the unknown. They beckon us to imagine what lies beyond the gallery wall. Kapoor's task is to open a door and let us discover what we will.

Most of Goldsworthy's work is made solely from materials found on-site, photographed, and left to return to their natural state. But he will also take these natural materials into museums and galleries. Lois and I had the privilege of seeing one of these installations in the Glasgow Contemporary Art Gallery, in October 1997. The installation consisted of natural clay, which completely covered the floor of a small room in the gallery to a depth of approximately six inches. As the clay slowly dried during the exhibition, cracks developed, becoming increasingly larger and more numerous as time passed. In a statement on this piece presented in the gallery, Andy wrote,

The simplicity of the forms in these sculptures seems to reflect the artist's own search for the essence of all life. Since *1000 Names*, Kapoor has been making these essential forms in almost every conceivable material. Wood, sandstone, concrete, cast aluminum, clear acrylic, and Perspex shapes have all given their viewers a sense of motion, even of vertigo, as if they were falling or drifting right out of the material plane of existence. If approached with an open mind and much patience, art like this can also become a meditation or a visual prayer. From my own experience, I know this can be achieved with reproductions, but is naturally more successful when we see the original art.

The works of internationally acclaimed artists such as Kapoor, Goldsworthy, and Viola are easily accessed by anyone caring to look for them in books, at traveling exhibits, and on websites. They represent a mere fragment of the art that is being made. Many artists who are not in the limelight also make excellent work and contribute towards our spiritual evolution. There are artists doing this kind of work in virtually every community.

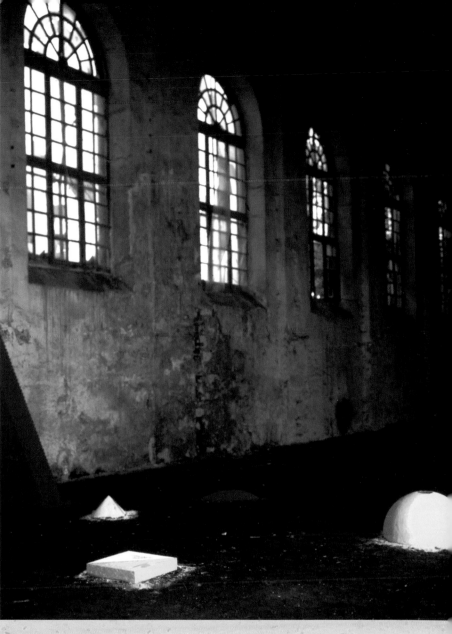

1000 Names; 1981
ANISH KAPOOR
Mixed media, pigments – 3 elements;
various dimensions

Shawn Serfas has recently moved to our area and is contributing much to the community, both as a teacher and as a spiritually focused painter. His energetic, mixed media abstract paintings guide us into the gap between the spiritual and material worlds. He develops them loosely and intuitively, with *accidental* marks that become integral parts of the composition. Shawn describes them as "a personal expression of nature's physical as well as creative presence."

They are made in a devout manner and can be viewed as visual prayers or mandalas. As with the work of Rothko or Tobey, the more time one takes with Serfas' paintings and the less one thinks about them, the more profound the experience.

It is Serfas' intention that his work explores ideas of *natural history, intelligent design (creation science), Christian theology, and the creative act*. I find it easy to get lost in these works, to drift from viewing the overall design to observing one of the richly encrusted circular forms, to observing the nearly figurative shapes that hover or float in space. In paintings such as *Radial Base Plain #2* and *Basin and Plain #11*, it is easy enough to see resemblances to actual objects, which is part of Serfas' intention. It is also his intention to explore the very act of creation which is continually taking place. By allowing the painted forms to exist in our minds simply as forms and not as anything that fits our definition of reality, we may come to an understanding of the totality of life.

Basin and Plain #11
SHAWN SERFAS
Oil, acrylic & nickel-based pigments on canvas

Shawn Serfas intentionally takes a non-objective approach to exploring spiritual connections. This makes personal sense for him. Others will take different approaches.

Like Serfas, Julie Elliot uses layers of spontaneously applied paint to help her visualize a spiritual presence, though she often uses representational imagery. Her painting *Send My Roots Rain*, in which a chair becomes the focal point in an otherwise chaotic field of almost recognizable marks and lines, is a fine example. She wrote her artist's statement for this work as if the chair itself was speaking to us. Both the chair and its thoughts can be read as strong metaphors for the self.

I am alone but not lonely. I am connected to the core of the earth. My roots — fibrous, black, water filled — stretch out to connect and grab hold of what's next. Water swirls around my head and washes down to a bulb that's filled with potential. My world is organic; moving, shifting, changing. It moves out and in and around. I wait. All is quiet here. Just me and God and the smell of the earth. I sink into this time and place. Sometimes it is best to do nothing.

The chair in Julie Elliot's painting serves as more than a metaphor. It helps us see the otherwise random marks around it as sky, earth, and roots, which can allow easier access to the picture. My first response was to view the white marks between the chair and the deep roots as light energy. This is not how the artist envisioned them, but when I told her my response she had no difficulty with my alternative interpretation.

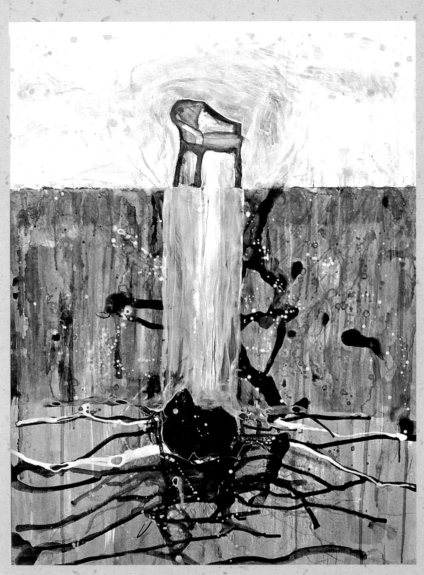

Send My Roots Rain, 2001
JULIE ELLIOT
Mixed media on paper;
76.2 x 55.8 cm

Lois and I have each made a wide range of art which also addresses the transcendence of life. We discuss Lois' small works on paper and her installations in other parts of the book. She has also created a series of large oil paintings that purposefully address spiritual issues.

The first painting in the series, titled *Work in Progress*, is my favorite. It responds to the title *Our Relationship to God*, and is boldly painted in primary colors that make clear statements about our spiritual growth. Before she painted this series, Lois spent several years making very little art and suffered from this deprivation. The experiences that led to this work were liberating and empowering for her. In her written

Work in Progress (detail); 2005
LOIS HUEY-HECK
Acrylic on canvas; 152 x 244 cm

statement for this piece, she stated," I wrote and thought about how I've been in exile from my creative self. Then came the recognition that it has been impossible to be fully in relationship with the holy because a huge part of me (the creative part) has been absent."

This piece represents her breakthrough.

The figure on the left is dancing towards the light. On the right, she stands open to the universe. Lois says, "The figures are naked because I am learning to stand in my naked truth before God and before myself."

The two snakes in the painting come from a dream she had and she understands them as symbols of transformation. Although she has often painted with more subtlety and sophistication in other works, I find the scale, the simple strength of the color scheme, and the thorough honesty of her personal expression to add up to a clear message about our lives and our place in the greater scheme of things.

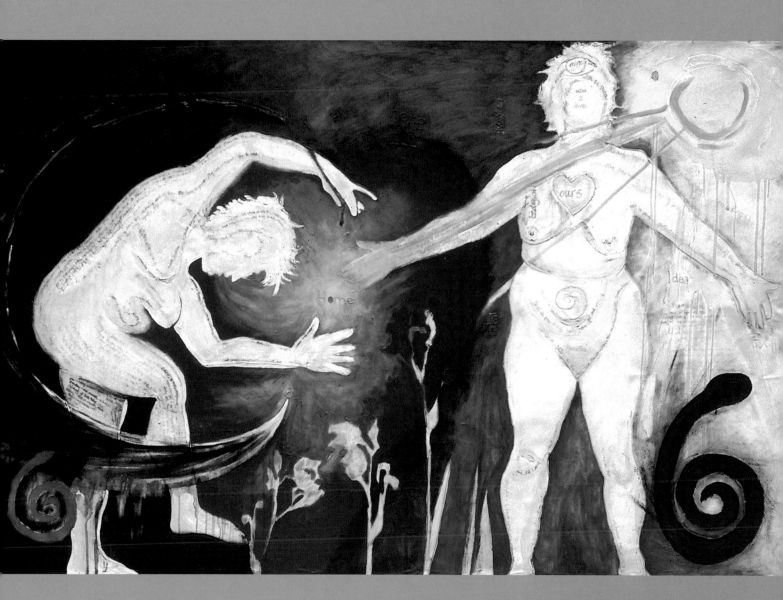

Work in Progress; 2005
LOIS HUEY-HECK
Acrylic on canvas; 152 x 244 cm

57

Although much of my own work is derived from and directly relates to the natural world, there are times when I seem to stumble out of the forest and take notice of the human civilization all around me. This first happened while I was still at art school, in Vancouver. I was standing in the pouring rain on Hastings Street, waiting for a bus, and generally feeling sorry for myself. I stood by the graffiti-covered bus stop bench, wishing for a dry place to sit, staring at the garbage around my feet. I was trying to ignore the drunk across the street who was yelling in my general direction, and the effort focused my attention on a soggy cigarette package and a slowly dissolving newspaper. As I stared at them, something shifted. I was suddenly aware of the raindrops falling past me like little silver rockets. Then they burst on the wet paper and the concrete around it in tiny explosions of light. The rain fell in a steady rhythm, which I now perceived as a pulsing rhythm of tiny explosions of light. This light was bouncing off everything in my field of vision. As I slowly lifted my gaze, I saw light shining everywhere – off the street, the power lines, the sad shops, the other pedestrians, even off the bellowing drunk across the street. I stood transfixed, no longer wet or sad, until the bus came to take me away.

That perspective comes back to me sometimes and with it a calm acceptance of all that is. When I can accept the human world as easily as I accept the rest of nature, everything does indeed begin to glow. While my current art is still based in the beauty of nature, I find myself wanting to put everything – from land forms and animals to signs of civilization – into them, indiscriminately and uncritically. More and more, I am seeing the connections between nature and culture.

Terms of Endurement is the first of this recent series of large, mixed media drawings. The river gorge at the top represents the source of all life, which endures beyond individuals. Everything has its day and then it is gone, but something else will fill the void. Life endures. The golden glow that is the underpainting seems to work to hold all the different parts of the drawing together. I included it impulsively; perhaps it is the glow I saw in everything many years ago on Hastings Street in the rain.

The artists represented here stretch the definition "giver of the sacred" a long way. No doubt it can be stretched further. You may have had your own experience with art that was a source of revelation for you, either as an artist or as one who appreciates it. Within the range and complexity of art as sacerdos, we each become aware of a little of what is possible. Quite likely, we only become aware of what we need.

FOR AN ART/SPIRITUAL PRACTICE
RELATED TO SACERDOS
VISIT THE WEBSITE:
WWW.SPIRITUALITYSERIES.COM

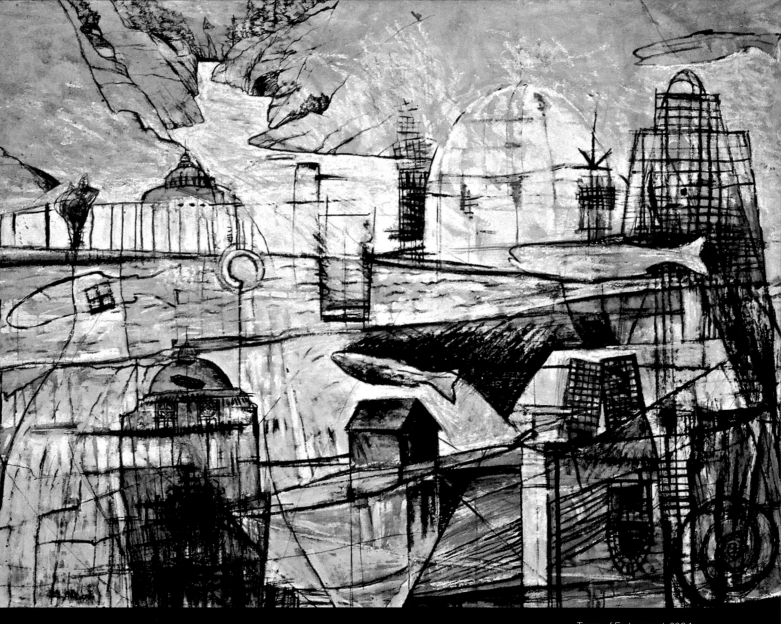

Terms of Endurement; 2004
JIM KALNIN
Mixed media on canvas;
152.5 x 203 cm

3 Art as Healer

Lois Huey-Heck

Theodokos and Child
HEIKO SCHLIEPPER
Icon, 64.0 x 2.9 cm

A statue of Mother Mary stands near the entrance of the Rosemary Heights Retreat Centre. The morning after I'd arrived at the Centre I found myself drawn to her on my prayer walk. The stream of Protestantism in which I grew up made Mary conspicuous by her absence. Given that history and my mixed feelings about the way Mary has been portrayed through the centuries, I wondered why I was there that morning. It wasn't merely idle curiosity, nor was it unquestioning devotion. I was there spending time with Mary because it was what I needed to do.

The statue is classically beautiful, the surroundings simple. It bears a dedication plaque from a woman to her parents and brother. Mary is standing, eyes lowered, hands open. I noticed that the once all-white Mary was a bit dusty, her paint was cracking, and there were fir needles and other plant-matter stuck to her. There was a spider on a web spun between her open hands.

My first inclination was to clean her off, thinking "our Lady" should not be covered in dust and spider webs. But then it seemed right to leave her and the webs undisturbed. Watching the spider with an odd mix of wonder and revulsion, I saw something I'd never seen before. The spider picked up some debris and threw it out of the web. "Just like Mary," I thought, "gotta clean off some of the junk that's been dumped on her over time."

I found myself saying, "Mary, Mary, what must you think of what we've done to you?"

The question goes many layers deep and comes out in a tumble of grief, empathy, and anger. I feel the gaping hole in Western religions, where the feminine face of God belongs. It's a loss with cataclysmic consequences for individuals, for the human community, and for the health of the whole planet. All of human life is about the dynamic relationship — external-biological and internal-spiritual/psychological — between the feminine and masculine. None of us exists except by the biological union of feminine and masculine. I would also say that none of us is ever whole and fully matured until we bring our inner feminine and inner masculine into union. Jungian analyst Marion Woodman says this inner marriage is our greatest creative act. In many ancient traditions we see both masculine and feminine in the divine. This creative interplay is depicted in the Eastern yin/yang symbol, where it's not a war between the sexes. The yin/yang symbol shows the masculine and feminine in a dynamic, symbiotic relationship, where each *force* or energy includes a piece of the other. It's a far cry from the mythology of dualism.

And so it seems absolutely right that Mary starts this reflection on art and healing, because of the miracles of healing attributed to her all around the world. Regardless of how we each understand the phenomenon, the fact is that something powerful is at work for the inestimable number of people who come to Mary for healing.

There's no shortage of situations in our world that need healing and I can't do justice to them all here. I do, however, want to tell stories of how art is healing to people who are marginalized in some way. I also want to tell a story and show the images of an artist who is reconciling religion and her creativity; introduce you to a First Nations artist who has brought the pictographs of her ancestors into contemporary form; and let you hear from a woman who creates ritual theater. In the end, I will come back to the beginning by revisiting images of Mary and what they have to teach us about becoming whole.

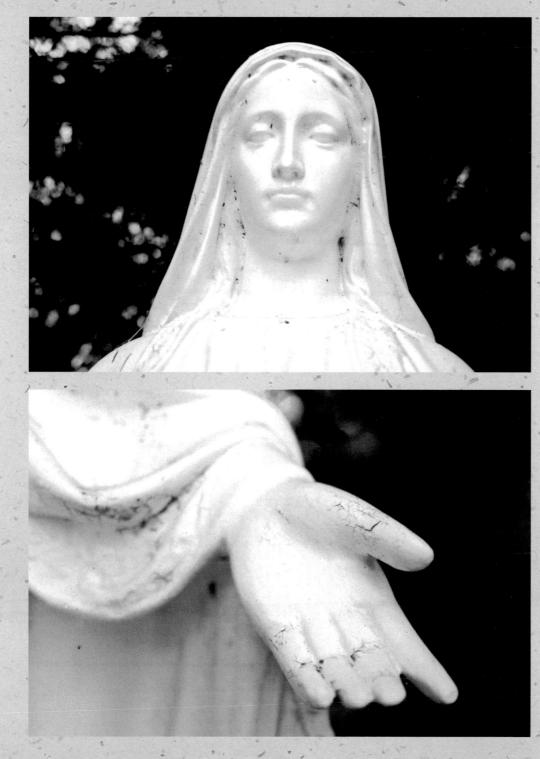

Blessed Mother,
Trusted friend,
companion, sister, and
comforter –

Thank you for removing
the blinders from our eyes
that we might see reflected
in you the full potential
of girl and woman.

Thank you for mothering
us into maturity where
we no longer need to cast
our refuse onto your
image.

Thank you for helping us
find the voice to speak
on behalf of the victims
of violence and oppression
everywhere.

May your fierce mothering
love make compassionate
healers of us all.

May we, who also live
under your cloak of
compassion, extend mercy
and hospitality to all
of creation.
Amen.

LOIS HUEY-HECK

63

ART AND ARTISTS

While this chapter doesn't focus primarily on formal art therapy, art therapy does deserve mention. Some years ago I had the good fortune to experience art therapy first-hand. The process of reflecting on my life through images was potent. I was amazed at how directly I painted my unconscious beliefs about myself, others, and our relationships. Art therapy also introduced me to expressive art forms.

Most of us are pretty good at directing conversations in order to avoid what is shameful or painful for us. One of the great contributions of art therapy (and music and drama therapies) is that we don't know how to hide ourselves (even from ourselves!) behind art the way we can hide behind words. Also, art therapies are successful with people with cognitive limitations, because art relies on and develops *other* parts of our vast brains – besides our language centers.

Steve's Painting; 1987
STEVE HECK
Oil on canvas board; 30.5 x 25.5 cm

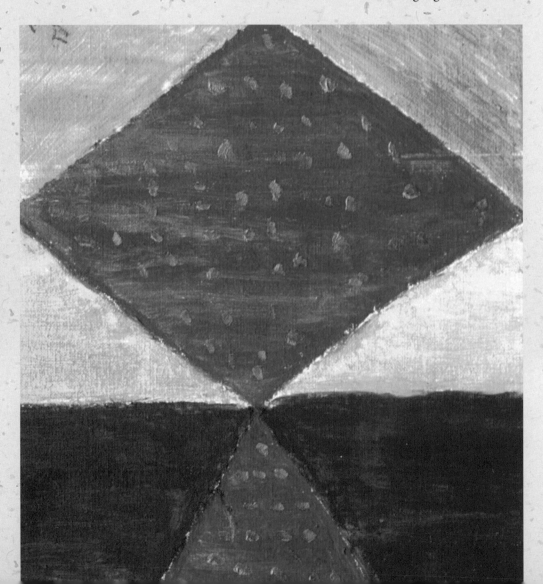

Steven, my first husband, suffered a head injury in 1983. It was 13 months after we were married and a few months before our son, Bryan, was born. The damage to Steve's brain was mostly to the left frontal lobe, which makes finding and comprehending specific language extremely difficult for him. Fortunately, we had some good support and advice following Steve's debilitating illness. I learned that encouraging him to maintain his music (he plays acoustic guitar and sings) could help him recover some lost language.

Music acts as a bridge-builder between the two sides of the brain. You will know how true this is if you have ever had the experience of forgetting the words to a song and then found them (or some of them) by humming the tune. Melody belongs to the right brain while words and lyrics belong to the left brain. Children born with left-brain head injuries have been taught to speak in musical classrooms. With a sing-song lilt to their voices, these children access the damaged left hemisphere through music. For Steve, music remains an important part of almost every day.

In the early years after Steve's illness, we explored other creative right-brain activities that he enjoyed and could have success with. On the left is one of Steve's first paintings and below, one of his original rug designs. I wish I could tell you that the arts cured Steve completely, but music, making wonderful rugs, and our forays into painting did not fully remove the effects of Steven's head injury. That they contributed to his recovery and to his quality of life is inarguable. Because Steve's right brain is mostly undamaged, he gets a great deal of satisfaction from these non-linguistic pursuits. In the process, he has generously gifted all of us who know him with hours of music, wonderful warm floor rugs, and some great little paintings. These are ways Steve can be a part of and make a contribution to the community around him.

Every activity that calls upon seldom-used parts of our brain expands us. While the benefits to someone like Steve are dramatic and obvious, we all benefit from right-brain activities such as meditation, seeing/making art, hearing/making music, and writing/reading literature.

STEVEN'S STORY

We write, we make music, we draw pictures because we are listening for meaning, feeling for healing.
MADELEINE L'ENGLE

Steve's rug; 1988
STEVE HECK

Beth doesn't think of herself as an art therapist. She started volunteering with the Prostitutes Empowerment Education and Resource Society (PEERS) as a result of her personal interest in another biblical Mary – Mary the Magdalene. While Mother Mary has carried our projections of woman as impossibly pure, Mary Magdala has carried our projections of "fallen" woman. Beth has found Mary of Magdala to be a sympathetic character, a character speaking for the outcast in society and for the outcast in each of us. I see Beth's compassion for those who work as prostitutes as an act of service to and an act of redemption for Mary of Magdala.

Among its range of services, PEERS offers a 12-step program, this one for prostitutes who want to deal with their addictions. Following the Alcoholics Anonymous model, people who participate must acknowledge a higher power. Beth describes not only the healing experience of program participants, but also her own transformation.

I heard a "call"! On November 8, 2004, I went to PEERS to volunteer. What I found there were people who had given up on the "ideal" of what it is to be a human being in society. They do what they do to survive and survival takes center stage. Spiritual matters, it would seem, are far down the list. But here are some of the pictures of work done by participants of my small group when asked to look at their "higher power," along with some of their comments..

'Ray' drew a picture of a place where he feels the most at peace. He told a story about a time when he was in Italy, when his grandfather died. When he found out his grandfather had passed, he ran to their favorite spot, and this favorite spot was the picture he drew. I asked, "When you think of this place, do you find your grandfather there?" He thought for a moment and then said, "yes."

'Laura' said that her collage was about hope and peaceful things. She explained that she did not know why she picked the things she did, she just knew that those things spoke to her. She said, "I feel that I am making a mandala." Asked what that was, she responded, "Something you stare at so you can remember things."

'Sheri' drew bursts of light. I pointed out that it all came from one center. She was intrigued with that idea, saying "You are right. It all started from one place."

'Barbara' is the depressed one. I gave her black paper and a white pastel. I wanted her to transform her darkness, which she did — but then she caught me and colored the white with red. After she added the stars and water; she transformed a "lifeline" into a "city line."

I believe that deep within all of us lives the soul or the "child of humanity." Through the cracks in the insanity of prostitution and their very difficult lives, Ray, Laura, Sheri, and Barbara were able to speak about their artwork using words like "peace, hope, centeredness, transformation, and soul-speak."

In the moment of their sharing, we all encountered the holy. The room went silent, their faces changed:

"Come no closer! Remove the sandals from your feet, for the place on which you stand is holy ground"

EXODUS 3:6.

I removed my sandals. The first hour and ten minutes we shared was filled with community building, meditation, three deep breaths, and laughter. In the last 20 minutes, we were on holy ground. I found God in the chaos. I had the profound opportunity to see the duality in physical prostitution, where people appear so far from God, yet they are closer than I had imagined. They were receptive to the message of the divine.

'Regina' created this picture while in hospital. Etched into all of the many colors are the words, "see me."

Beth concludes,
I see her, a child of God.

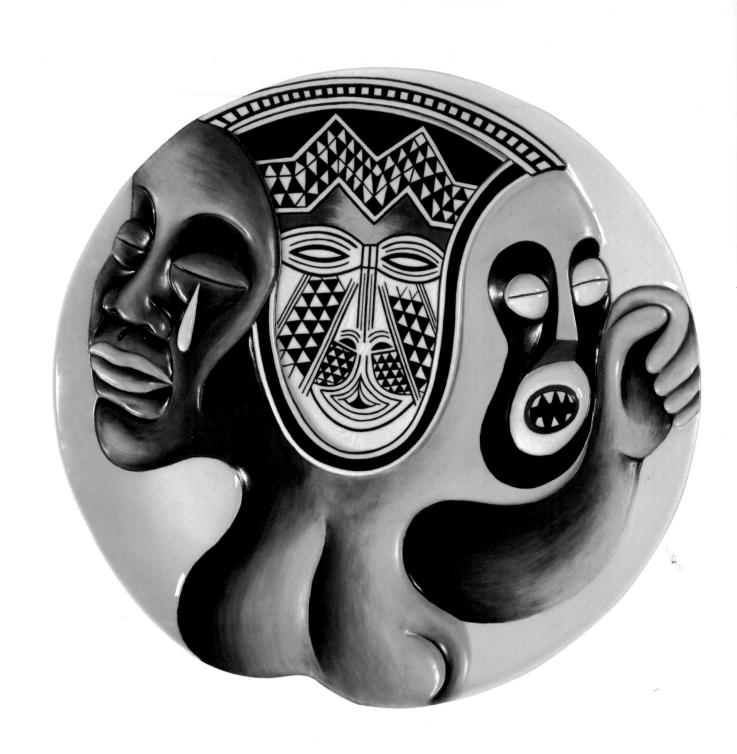

Judy Chicago's installation *The Dinner Party* was a ground-breaking event for contemporary women and women artists presenting images and ideas in honor of women and feminine deities. Chicago worked with a team of people to build the multimedia installation, though she designed all the actual artwork herself. The triangular installation of table settings honors women throughout history and is an echo or perhaps a parody of Leonardo da Vinci's *The Last Supper*. It stands as a celebration of feminine creativity, and found a huge following despite being ostracized by much of the art establishment. It helped burst open the floodgate of women's creativity in the arts. This epic work required years of collaborative effort, creativity, and support from a team of artists.

THE DINNER PARTY — JUDY CHICAGO

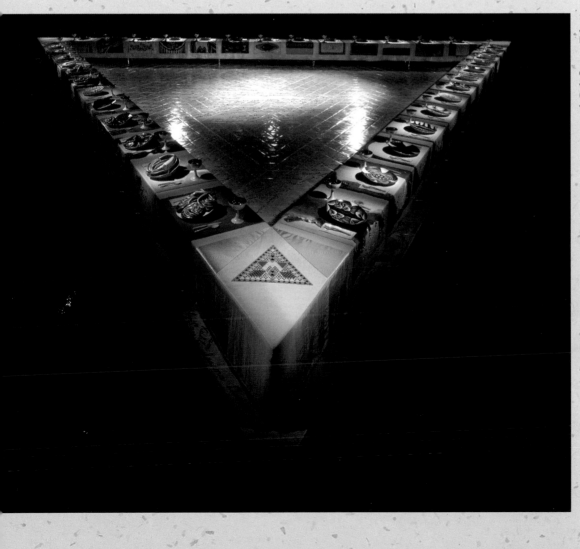

The Dinner Party; 1979
JUDY CHICAGO
Mixed media installation;
1464 x 311.5 cm

opposite:
Sojourner Truth Plate; 1979
(detail from "The Dinner Party")
JUDY CHICAGO

KIM'S JOURNEY

Kim Andresen's work as a healer, her path into art, and her spiritual quest have all turned out to be one journey. As a mature student in her Bachelor of Fine Arts program, Kim found her spiritual quest to be a solitary one. The post-modern art world is still largely self-important and still largely identified with outmoded modernist notions. As such, there's barely tolerance for the spiritual quest and no tolerance (in most quarters) for the religious. Kim found, as an art student, that she developed styles of working with intuition and with materials that were compatible with her spirituality at the time. She enjoyed using ordinary, everyday materials – things we think of as worthless – and transforming them into art. It allowed her a tentative peace with the art world. To her surprise, however, her spiritual quest and her art-making have taken a totally unexpected turn. Describing these events, she says,

Four years ago I walked the 1200-year-old Christian pilgrimage across northern Spain, the Camino de Santiago de Compostela. I had no idea why I was walking a religious pilgrimage – I had not been inside a church for many years. I just had an unexplained need to make that pilgrimage. When I returned, I began filling my studio with paintings of crosses. I told a few people about the cross paintings, but I showed no one. I always said, "They are not about religion – the cross is an archetypal symbol for relationships." At the time I believed that I was just continuing to paint the relationship of culture and nature and was merely using the symbol of the cross.

The denial of any connection between my paintings and Christianity runs parallel to my stopping painting. I experienced a spiritual crisis, which sent me into the interior world where I read and wrote intensely. Emerging eight months later I knew that my path was through Christ, but I was still uncomfortable with the naming. In the same way that I hid my paintings of the crosses, I hid my religion. I knew that I was to paint, yet it was a struggle, as it was a struggle to admit that I am a Christian.

Birth; 2005
KIM ANDRESEN
Acrylic on Masonite; 15 x 40.5 cm

Second Station, portrait of Jesus; 2005
KIM ANDRESEN
Acrylic on canvas; 40.5 x 51 cm

Part of the dilemma for progressive-minded Christians – internally and externally – is that the version of Christianity most often espoused on television and radio is an abomination to us. The rhetoric of the religious right is actually contrary to the God and Christ we know and strive to serve. In Kim's words,

Although I can say quite clearly now that I am doing contemporary Christian painting, this has been a difficult journey for me in a world where Christianity is often associated with fundamentalism, with needing to be right, with being the only way. That attitude towards Christianity is far away from my beliefs and from my knowing. The clarity has been a struggle as has been my journey to God, which I've fought against most of the way!

Recently, Kim has been working on a series of portraits of Jesus – the many faces of Jesus, of different skin colors, with different expressions – Jesus of the 21st century. In these portraits, Jesus stands behind a close-up of the cross, which often appears as some kind of window frame. Kim says that in naming her Christian beliefs,

All the unseen barriers, which have blocked the painting for years, melted away. My spirituality goes through Christianity. My art goes through Christianity. I am expanded through knowing that we are all different and beautiful – to follow our own path we can each bring the specific, the global, the cosmic, into the heart – together.

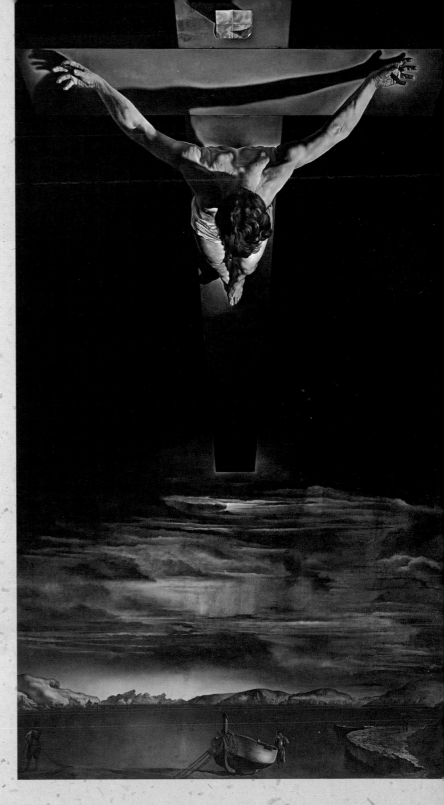

St. John of the Cross; 1951
SALVADOR DALI
Oil on canvas; 204.8 x 115.9 cm

TANNIS HUGILL

Like Kim and Beth, Tannis is a spiritual director. She is also an artist and a dance and drama therapist. Tannis describes the importance of art in her life.

As a young artist living in New York I was riveted by Native American art and inspired to make theater that achieved the same resonance as the Northwest Coast rituals. I was able to watch the rituals on movie footage taken by Edward Curtis in the early 20th century. The rituals moved me because everything was alive with spirit and the non-material world interacted fully with our reality. This connection of material and non-material realms instructed, inspired and brought greater meaning to my own life.

Over the next years I unconsciously succumbed to the secular pressures and influences of the New York art world, but then I began to work with people with disability and re-connected with the healing power of art. This led to my discovery of the wounded-healer archetype, and to my becoming a dance and dra-

ma therapist. It is here that I rediscovered the relationship of art to spirituality, and my journey led me back to the origin of my art-making inspiration. Now I make ritual theater, a new yet ancient form that must be re-introduced into our culture, though it has really never vanished.

For me, all creative acts are sacred. They have the possibility to bring us into a place of felt wholeness, of being fully integrated as ourselves with the larger cosmos. Unfortunately, in this culture we deny, or worse, malign this truth and remain disconnected, isolated from ourselves and the divine. We see and feel the tragic consequences of this everywhere, but aware or not, spirit lives in us and does its loving, redemptive, healing work.

Tannis' ritual theater is a stunning example of moving ahead by reclaiming the best of our history. The photos shown here are video stills from a ritual done outside the University of British Columbia Museum of Anthropology. Tannis' art demonstrates another way in which truth, beauty, and divinity are being found in our ancient roots.

untitled; 2005
TANNIS HUGILL
Stills from Video

Barbara Marchand is an artist living and working in the Okanagan Valley of British Columbia. Barb creates amazing installations and art pieces that integrate the gifts of the land and the arts of her First Nation. She is a multi-media, multi-disciplinary artist working in two and three dimensions.

The three stones shown here are part of a larger installation, which covered a wall and part of the floor of the gallery when the stones were first exhibited. They were a gift to us from artist friend Jennifer Macklem. Barb began this work by creating her own pictograph – a painting on stone that represented her. She then took a photo of what she describes as a small and simple image. The image was then translated by a computer into ASCII code. Barbara says,

the file was huge – it was surprising how technology turned that simple little image into pages and pages of ASCII code. It's a metaphor for how technology can make the simple, basic things so complex.

Finally, Barbara extracted bits of the ASCII code at random, *almost as if it were an alphabet,* and painted it back onto pieces of stone. It's a brilliant progression.

In her own words,

these small painted stones also represent the way the historic pictographs are being defaced. People have actually chipped away the stone in order to take the images.

For me, Barbara's creative response to historic pictographs, the defacing of same, and the *intervention* of technology in our lives brings the cultural tradition of painting on stone into our century. The new pictographs are at once social critique, honoring of tradition, and a celebration of the human creative spirit.

The File displays a paralell between saving information on the hard drive of a computer to an acient form of "saving" information by means of the pictograph.

from the larger work, *The File*
BARBARA P. MARCHAND
Smallest to largest:
8.6 x 9 cm, 12.4 x 10 cm, 34.5 x 7 cm

73

AFTER THE FIRE: CHRIS' HANDS

A heavy frost covered the land on the morning Chris took this photo. He'd gone out walking in the mountains that had been seared by forest fire the summer before. He placed his hands on this frosted rock face until their warmth melted the ice. His hand prints revealed the soot blackness and the remaining traces of the red fire retardant. This is a captivating image – at once as primal as the hands painted, stamped, and outlined on cave walls – and as modern as chemical fire retardant and fighting fires from the air. The image is timeless and temporal – that's its healing gift to us.

Impression; 2004
CHRIS DUGGAN
Photography

When the Kettle Valley Railway trestles were burned in the forest fires that struck Kelowna, British Columbia, in 2003, Margaret Kyle offered her art as way to help the rebuilding. Prior to the devastating fire, she'd painted one of the trestles in the brilliance of autumn. Working with friend Robert MacDonald and her husband, Mike, Margaret had posters made of her painting and donated the profits for the restoration of the historic rail bridges.

Margaret describes the importance of the trestles to her family,

Having grown up in Kelowna, the historic Kettle Valley Railroad and the trestles were often mentioned in my home; my father Perry Kyle had been attracted to railroads since childhood. Later the canyon and trestles became a favorite spot to take my own children or any out of town visitors who wanted to see the sights. Now we are all so saddened that all but four of these trestles have been destroyed in the fire and we want to do our part to help raise money for their restoration so that they can again be enjoyed by visitors and residents alike.

AFTER THE FIRE: MARGARET'S GIFT

Kettle Valley Trestle #4; 2003
MARGARET KYLE
Watercolour on paper; 61 x 38 cm

MARY

I'm glad for the inclusiveness of the quote below at left. It gives me courage to approach the subject of Mary even though I'm keenly aware that there's much I don't know. I also appreciate the quote for the reminder that Mary transcends the narrow confines we usually imagine for her.

That's also what attracts me to the sculpture The Original Face, by Frederick Franck. Franck's seven-foot metal sculpture is based on medieval statues, where the flaps over Mary's stomach opened to reveal the Trinity within, but in Franck's sculpture the doors open to reveal "the Buddhist idea of the original face that every human has before conception." He has made a link between the Buddhist original face and the concept of the Immaculate Conception, which he interprets to be "a sign of revelation about all human beings." I appreciate this image of a more universal Mary to go alongside the more specific and human representations. It reminds me of the paradox of a God utterly beyond our comprehension, who is closer yet than breathing.

Original Face
FREDERICK FRANCK
Metal; 2.135 m high

…Mary has met with a powerful response all over the world. In Western culture and in Christianity – even in Islam – she occupies a prominent position.[2]

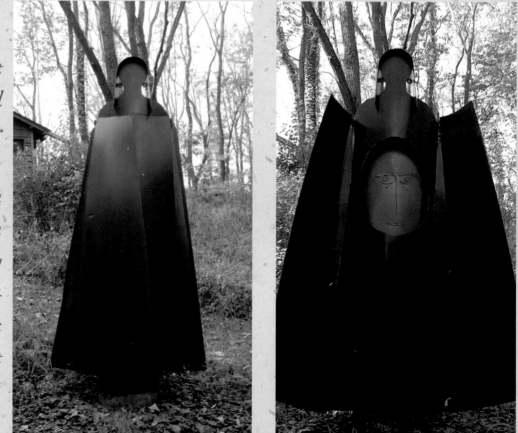

And what would any conversation about Mary – no matter how brief – be without a Madonna and child? Giovanni Bellini's *Virgin and Child* is such flesh and blood you can almost feel the infant squirm and know the tiredness of the mother. They're very human figures with emotions that make them accessible to us.

The first morning I met the Mary at Rosemary Heights I had all my *baggage* along, including my critical thinking. In particular, I struggled over the ways Mary-the-symbol has been co-opted to subjugate women and girls. I longed for true acknowledgment and inclusion of the feminine in all aspects of life (especially in supposedly religious corridors). In the midst of this, my judgmentalism was transformed into empathy for the girl/mother/woman Mary, who carries so much for us. It was a reconciling encounter.

My eyes followed the sensuous folds in Mary's garments. There was a sense of movement, a subtle optical dance in the fluidity of the form, but it ended awkwardly in a coil around Mary's feet. I thought the sculptor had really erred by adding this contrived shape – almost like a frame at the hem of Mary's robe. However, as I followed the odd shape around to the front of the figure, I saw that Mary's foot was on a snake. The snake's mouth was wide open in what appeared to be its last gasp. I was completely taken aback.

Madonna and Child
GIOVANNI BELLINI
Oil on canvas; 47 x 34 cm

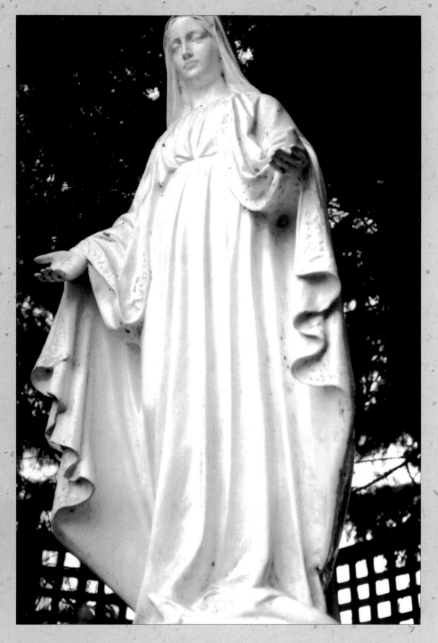

FOR AN ART/SPIRITUAL PRACTICE
RELATED TO HEALING
VISIT THE WEBSITE:
WWW.SPIRITUALITYSERIES.COM

Puzzling over the snake it dawned on me: "This is Mary as the new Eve."

I admit my first reaction was not kind.

"Here we go again," I thought, "Mary against Eve. Submissive Mary redeeming the "original sin" of the precocious Eve. And the poor snake turned from ancient symbol of transformation and regeneration into a symbol of evil-incarnate, maligned through the centuries along with Eve and her oh-so-human sisters."

I knew that two of my friends had also spent some time with the statue of Mary and I asked each of them if they'd seen the creature. They hadn't. I went to Mary with each of them in turn and we stayed until they found the snake. They were both as surprised as I was! One of them spoke to the Anglican sister in our group, Doreen, and asked about the snake. I loved Doreen's response. She said that Mary standing on the snake is a symbol of freedom. I like that. I hear in that statement the promise of freedom from the inner tyrant of compulsion, freedom from the external forces that oppose truth and beauty, and freedom from living half-lives.

The great thing about art is that both these interpretations and a whole lot more can be true. Thank you to those faithful ones who gave Mary presence at Rosemary Heights. Had she not been there I would have missed the experiences and the learning.

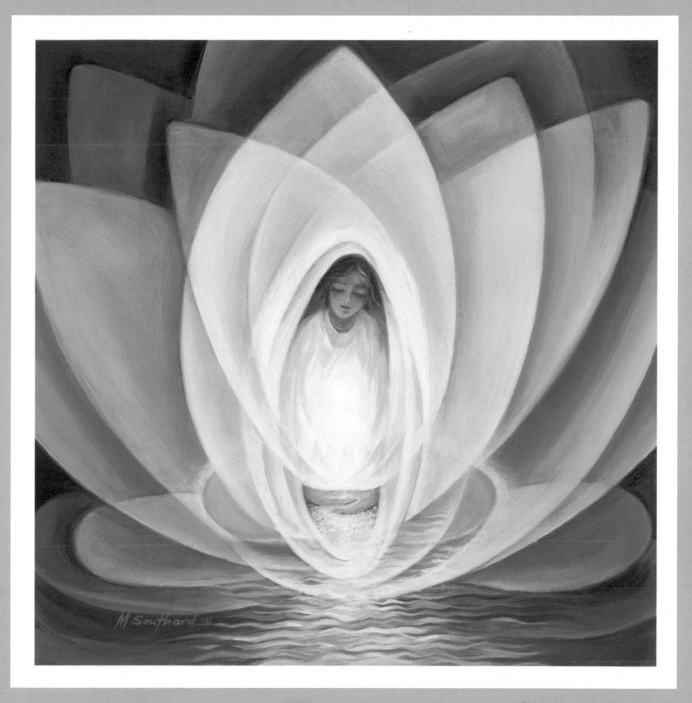

Divine Light
MARY SOUTHARD, CSJ, 2003
Acrylic on board, 34.3 x 34.3 cm

4
Art and Conscience

Jim Kalnin

Spirit moves in different ways. In order to heal the many wounds that occur in life, we must often embrace the pain and stand up in the face of oppression. Not all of our spiritual work is done in the safe and peaceful confines of a sanctuary. This chapter explores some of the tougher forms of spirituality and art that at times may stretch the definition of both.

Tigiani; 1989
MICHEL TUFFERY
Woodcut on flax paper; 76.5 x 54 cm

In 1975, I spent some time on the Caribbean island of San Andres, which is a territory of Columbia populated by English-speaking citizens. Near it are a couple smaller uninhabited islands, or cays, with a few bars and restaurants, to which tourists and locals were boated daily from the main island. The days had a relaxed and festive feel and I was enjoying painting and drawing, and meeting Columbian tourists, world travelers, and the locals. I caught the first boat over to Johnny Cay each morning, arriving to the smell of fish frying in coconut oil and the strains of calypso music floating on the breeze. I spent the early hours of each day painting a watercolor portrait of old *Pops*, and listening to his stories, as he sat cutting up fish for the day's fry. When he had finished for the day, I would paint other things.

Christ is a Fishermanl 1998
BAGONG KUSUDIARDJA
Oil

One day, I sat in the sun eating from a paper plate of fried fish and vegetables, and idly painting over a disastrous portrait from the day before, when Joseph, a young man with dreadlocks, sat down next to me and asked if he could paint a picture too. I said *sure* and handed him paper and a brush. He talked and sang songs nonstop – mostly to himself it seemed – while we worked. The songs were revolutionary; the words were about living a life of strife. I quietly listened to him as I worked. He talked about his painting and at times seemed to be talking to it. He began referring to it alternately as *him* or *them*, then as *these my savior*. Finally, he showed it to me. A face filled the paper. It was painted in bold strokes and bright colors, and had a heavy line running vertically down the middle. Above the left side of the head floated half a golden halo, and below it were soft, angelic features. The right side of the head sported a tam, a beard, and an angry scowl.

When I asked Joseph who the two people in his painting were, he said, "No man, it's Jesus and Che Guevara. They the same; they the same."

The same person, he meant, and the same savior. Guevara, the Argentinian Marxist revolutionary, had became a symbol of hope for suppressed people all over the world – especially in Latin America –

the same as Jesus. I left San Andres a couple days later and never saw Joseph again, but he was often in my thoughts. I traveled from the Caribbean into South America and often saw – in people's homes, and in restaurants, hotel lobbies, and on buses – a picture of Jesus hung next to a picture of Che.

People in affluent cultures may find the idea of these two figures being the same person an extremely difficult one, perhaps even a sacrilege. Impoverished people in Third World countries, however, don't have the luxury of such thoughts. Daily survival occupies all their time and energy, and, as devout as they may be, whatever thoughts or images they can muster to help them cope with war, oppression, poverty, and death they will gratefully use.

Particularly in times of struggle, the dividing lines between our spiritual and physical needs often get blurred. Mahatma Gandhi, Nelson Mandela, Martin Luther King Jr., and many others followed their hearts and the needs of their people from the pulpit to the political arena. In this respect, they had some of both Jesus Christ and Che Guevara in them. While we may not share Joseph's view about the two most important figures in his life, we might understand how the lines between them have dissolved for him.

ART AND ARTISTS

Joseph's highly personalized and unconscious response to injustice in his life is only one example of spirit using art to deal with adversity. The story of the Chilean Arpilleristas' bravery and spiritual focus in the face of terror can inspire us all. In 1973, the military dictatorship of Augusto Pinochet overthrew the democratically elected Chilean government of Salvador Allende. Many Allende supporters, considered a threat to the dictatorship, were rounded up and murdered or imprisoned. The wives and mothers of the missing searched the prisons and questioned the press in a vain attempt to locate their loved ones. Eventually, they turned to each other and the craft of making arpilleras, or tapestries, which they sewed from recycled clothing and other materials, as a way of expressing their grief.

In her book *Tapestries of Hope, Threads of Love: The Arpillera Movement in Chile 1974–1994*, Marjorie Agosin writes,

The arpilleras were born into a desolate and muffled period in Chilean culture, when citizens spoke in hushed voices, writing was censored and political parties vanished. Yet the arpilleras flourished in the midst of a silent nation, and from the inner patios of churches and poor neighborhoods, stories of cloth and yarn narrated what was forbidden. The arpilleras presented the only dissident voice existing in a society obliged to silence. The harsh military dictatorship that stressed domesticity and passivity was disarmed, muzzled by the Arpilleristas, who through a very ancient feminine art, exposed with cloth and thread the brutal experience of fascism.[1]

Chilean Arpilleras
ARTISTS UNKNOWN
Tapestry

An artist is someone who cannot rest, who can never rest as long as there is one suffering creature in this world.
MADELEINE L'ENGLE

These women used their art as a direct response to their situation. They did what they could to heal themselves by using their creativity to counteract brutality. They are not alone in responding to injustice and war in this way. Photographer Steve McCurry documented an Afghani artisan who used a cutting torch to turn bombs into flowerpots. The practical and poetic act of reusing the detritus of war to promote beauty is an act of protest and of hope by this man who lives with bombs. The artisan also hoped to sell his flowerpots, as the Arpilleristas sold their tapestries. As an artist, I find it satisfying to see these people resolving their poverty by making art from the events that caused their poverty in the first place.

Artists have long responded to the tragedies of others. One of the most famous examples is Pablo Picasso's epic painting *Guernica*, painted after the bombing of the Spanish town by that name during the Spanish civil war. An expatriated Spaniard living in France, Picasso felt the horror personally and turned to the best means available to him to communicate his anguish. His painting, and the awareness of the atrocities it exposed, inspired many other artists and writers worldwide, some of whom went to Spain to join the civil resistance against oppression.

Afghani Artisan, Qandahar; 1994
STEVE MCCURRY
Photography

In New York, Sue Coe reacted to the murders of the Allende supporters in Chile with a series of large mixed-media works on paper. One of these, *Pinochet 1973*, shows in graphic detail the mass murders his government committed in the back of the National Stadium. Her indignation is added to that of the women who suffered directly from this brutality.

Sue Coe and other artists who share her sensitivity to injustice have depicted the brutality that has existed, and continues to exist, in a wide range of situations; from former Apartheid South Africa, to slaughterhouses, prisons, and our own city streets, which are home to untold numbers of homeless people. These artists add their voices to other worldwide protests, which sometimes do work to bring justice to those who are being oppressed.

Coe's work and that of the Arpilleristas show us just a few of the vast range of responses that artists can have towards adversity. While we can easily see spirituality in the creative and visually pleasing responses of the Chilean women, it may be much harder to see it in Sue Coe's work. Does this mean it is less spiritual? Do not her honest and graphic depictions of brutality also speak clearly of the essence of life? Call it tough love, or in this case tough art. As much as we need beauty as an antidote to "harsh reality," we also need to be reminded of the ways in which we are out of grace, and of the work we still have to do.

Art of conscience can be found everywhere, in many different forms. Sharron Culos is an artist in our own community who has responded to the tragic murders of girls and young women by looking at how abuse has shaped her own life. A series of large, dark paintings and mixed-media installations made up an exhibit called *Led Down the Garden Path*, which was displayed at the Kelowna Art Gallery. One of the largest and darkest of these paintings, called *Three Sisters*, now hangs in our living room. Incorporated into the painting are cement, canvas panels, burnt aluminum, dried flowers, and acrylic paint. The dried plants in the black conical vases symbolize Sharron and her two sisters. Some visitors to our home have been confused or overwhelmed by this work, even when it was explained to them. Lois and I live with this painting and know and like the artist well. We are quite used to the dark colors and theme, which likely makes it easier for us to see the spirit and beauty in it. The darkness glows; light shines through the gloom in ways that suggest hope. The fragile dead plants, painted black, have a grace in them as well. The ritual act of the artist placing her childhood wounds into the care of her creativity has its own value. The act of revealing is in itself a healing ritual.

Three Sisters; 1994
SHARRON CULOS
Mixed media on canvas;
124 x 165 cm

The innumerable ways of turning pain and injustice into art can also lead us to personal growth experiences. Lois made installation art that was a reaction to another kind of abuse. The story is best told in her own words.

Some of my most personal experiences have given me the greatest sense of connection to the human family. One was giving birth. Another was losing my ability to give birth 16 months later, through cancer. In the first moments and days following each of those events, I had a great empathy for mothers across time, place, and culture. On the birthing bed, as I wept tears of celebration for a successful birth, I also grieved for those who gave birth only to lose their precious babies to starvation or stillbirth. Or who lost them before term. It was the same when I got the pathology report after cancer surgery. The relief was almost as ecstatic as what I had experienced at Bryan's birth, and immediately I felt for those who were not getting as positive a prognosis. (The violation installation I made was a continuation of this pattern that showed me how my personal experience was universal.) Years later, my annual checkup indicated that once again there were some abnormal cells in my body. Rather than take the recommended second surgery, I chose, in consultation with my MD and ND, to work with a number of alternatives in an effort to eliminate the pre-cancerous condition. We agreed that this was a reasonable course of action – with careful internal examinations at the hospital every six months. The procedure itself, called colposcopy, is invasive by nature. This happened twice a year for about three years, until I finally got a clean bill of health. Each visit plunged me into terror for my life. I wanted to live to raise my son, support his head-injured father, and have the chance to be an old woman. Each colposcopy seemed worse than the last. The specialist never spoke my name, never made eye contact, and was very rough. I was so traumatized I could not speak up for myself. The whole process – from the check-in and "gowning" to the intrusion into my body and the total neglect of my person – was a violation. In the midst of this time, I decided to build an art piece. I wanted to create something to convey an experience of this violation to the viewer. The project grew, however, far beyond my feelings and experience. As much as I hated being subjected to the procedure, I understood fully that I experienced only the tiniest fragment of what women, girls, and some men and boys live through. The sense of violation conjured up incest, rape, beatings, and torture. So while my motivation for making the piece was very personal, the installation itself was meant to speak for the violated everywhere – in far more dire circumstances than mine.

Building the piece was very cathartic. It gave me a chance to vent my anger, hurt, and indignation. I was in the studio working on the piece the morning I went for what turned out to be my last colposcopy (now 14 years ago). I resolved that if that doctor did one thing – anything – that offended me, I was going to challenge him. The anger broke my vulnerability and when I walked into the examining room that day the doctor actually looked up from his desk and said hello to me for the first time ever. It was an entirely different experience that day, because I was resolved to take care of myself.

It is vital that we understand ourselves as potentially both violated and violator, lest we fall into scapegoating. In the making of this piece, I had to face the parts of me that would violate the life/rights of another – we all have that capacity. I recall reading that when asked why she worked with the poor of India, Mother Teresa replied that she did it because she knew there was a Hitler inside her. When we acknowledge our potential for causing harm, we are less likely to act it out. It's hard work to face our own shadows but it is vital to making a kinder world.

Violation; 1991
LOIS HUEY-HECK
Mixed media installation;
dimensions variable

Lois' installation included two parts. The first was a small curtained "room" the viewer entered, which was completely lined with hangings of soft pink cloth. Certainly the term "womb-like" could be used to describe the room. I felt comfortable there, even nurtured and protected. The back was another pink wall, quilted and in two parts, that the viewer separated to reveal a huge metal hand, large metal tools, and a crudely painted face behind them. Although I knew this work, and had actually helped install it in the gallery, I still found it a shock when that hard vision of insensitive medical procedures and attitudes intruded into my safe pink environment. Lois had pinned an artist's statement describing the piece to an inner wall, in such a way that viewers wouldn't see it until they turned to leave the room. She felt it was important that they first have their own reaction to the two contrasting environments.

This exhibit was in an artist-run space and everyone in the show took turns "sitting" it. Doing so gave me many opportunities to experience others' reactions to this installation. These varied, with one viewer bursting into tears, and several being moved to relate similar experiences to each other, or to me, a total stranger. For Lois, the results were many. This piece helped her vent her feelings as well as it mirrored them. And she saw clearly how her own strength affected how others, including this doctor, acted towards her.

Violation (detail); 1994
LOIS HUEY-HECK
Mixed media installation;
dimensions variable

Many of my own responses to brutality in the world have stemmed from episodes involving nature. Several years after art school and my abandoned animation film career, I traveled extensively, worked when necessary, and made art sporadically. When I decided to go tree planting, I took art supplies with me. My first contract was near the north end of Vancouver Island, where I camped and worked for three weeks, with a dozen other planters. I spent much of that time in a state of shock. We were situated on a hill with a commanding view of the mountains that surrounded us, all of which appeared to be completely logged. Only a few small and damaged trees were left standing.

The work was hard but satisfying, except for the carnage all around me. For three weeks, I climbed over the slash (the mangled remains of the forest) planting seedlings wherever possible, while my art supplies lay forgotten in the back of my tent. Some cut-blocks we planted seemed not to have had the trees removed. When I asked a local logger about this, he told me that on difficult terrain they cut everything, but only took out the easiest 10 percent, in order to keep the company's profit margin high. It was at this point that my shock and revulsion gave way to anger.

Clearcut (detail); 1986
JIM KALNIN
Mixed media on paper

That evening I dragged out my art supplies and started drawing in earnest, making large, sparse charcoal versions of the devastation around me. These were bleak, rough and angry drawings, perfectly reflecting my mood. I continued to make them on subsequent planting contracts, and by the end of my second season I had amassed a fair number of them. I knew they weren't the finished work, only the preliminary drawings for it. It was several years before I reworked them into a series of mixed-media drawings, which were included in a traveling exhibit of art on environmental issues. Although clear-cut logging practices, such as those I saw, have largely been abandoned, I still find many reasons to be concerned about the health of this planet and these concerns still make their way into my art.

Art of conscience is not always critical. My angry clear-cut drawings are one kind of response. But we all see truth in different ways and respond in our art according to our own beliefs. Military dictators and their death squads may evoke a certain response from most of us, but there are exceptions. Rudolfo Arellano is an artist living in the Soledante Archipelago in Lake Nicaragua. Like others in his group, he works hard, and through the combined efforts of the artists

Corporate Interest; 1991
JIM KALNIN
Mixed media on paper; 112 x 154 cm

there, makes a modest income. Arellano is also a very spiritual person. His painting *The Good Samaritan* shows a Sandinista resistance fighter, the good Samaritan, aiding a beaten man who happens to be his sworn enemy, a government soldier. Arellano can look beyond politics and personal concerns and see that on the grander scale everything is connected, and everyone is related. We are all part of the same universe. My few experiences in sweat lodges and other ceremonies led by First Nations spiritualists taught me a very short prayer that sums this up quite well. It says, simply, "All my relations."

Art can also be made as a prayer. Adriana Diaz painted *Sisters of Clouds* as a friend lay in a hospital dying of cancer. It was specifically intended as a prayer for both women. Diaz writes,

We imagined ourselves in a state of being which no matter how we changed or where we went, we would be together as sisters.

The painting didn't save the life of her friend, but it eased the pain for both women. Sometimes that is all that a prayer, and a piece of art, can do.

FOR AN ART/SPIRITUAL PRACTICE
RELATED TO CONSCIENCE
VISIT THE WEBSITE:
WWW.SPIRITUALITYSERIES.COM

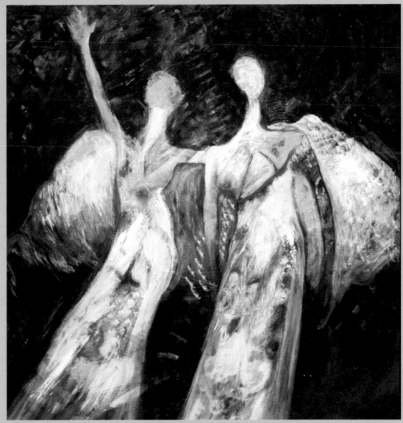

Sisters of Clouds; 1994
ADRIANA DIAZ

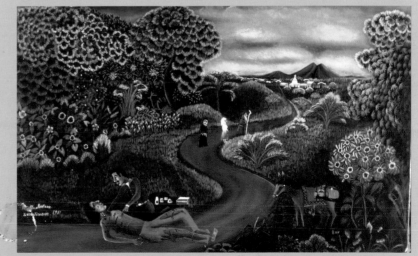

The Good Samaritan; 1981 - 82
RUDOLFO ARELLANO
Oil color on linen

5 Art and the Seasons of Life

LOIS HUEY-HECK

Across time, place, and culture, human beings have marked the seasons of life (*very* "thin" places) through art and celebration. Celtic Christians and their indigenous ancestors found the sacred *within* the rhythms of the natural world. Observation and celebration of the shortest and the longest days of the year, the spring and autumn equinoxes, and, the cross-quarter days[1] are ways of honoring spirit-in-matter. Each day offers the rhythm of light and dark; each month brings phases of the moon. Marking all these kinds of seasons gives honor to the Creator of the earth and affirms the place of the human *within* creation.

The world's spiritual traditions have evolved rich and complex rhythms and cycles, such as the Dream Time, the medicine wheel, the daily prayers of Islam, the Jewish annual cycle of observances, and the Christian Year.

Radial Base Plain #2
SHAWN SERFAS
Oil, acrylic & nickel based pigments
on canvas; 24 x30 cm

Spark of Life; 2002
LOIS HUEY-HECK
Mixed media on paper; 18 x 13 cm

In *To Dance with God*,[2] Gertrud Mueller Nelson makes a compelling case for intentional ritual and celebration. She cites the ways we fall into unconscious ritual when we don't observe the *seasons* and cycles. For example, many of us have given up (or have never known) the cycle of feasts and fasts that have been an integral part of the Judeo-Christian tradition.[3] As we no longer mark the annual round of spiritual fasting and feasting, we've unconsciously replaced them with compulsive dieting and bingeing. Appearance and weight control are what we now worship and they are poor god-substitutes for body and soul.

Each and every way of marking the seasons offers the opportunity to see and experience the sacred in life. Because we live in a global village, we have the opportunity to share our traditions; not in an attempt to convert each other, but as an act of peacemaking through which we share the best of our traditions. Thus, even though I focus in this chapter on the seasons of the Christian Year, I do so in the spirit of sharing a tradition that has deep meaning for me. While I've been blessed to take part in rituals and worship from several different traditions, and while my spiritual practice reflects a tapestry of traditions, the Christian Year is still the way I know best and can share with the most integrity.

I love the richness of the long tradition that is the Christian Year. Its colours, symbols, and stories, mark a cycle that, like the seasons in the natural world, has inner and outer layers of meaning. Each season in the Christian Year illuminates other seasons of our personal, community, and planetary lives. For example, Easter can mirror rebirth in the soul and in the natural world (in the northern hemisphere), while the Christian season known as *Ordinary Time* reminds us to find the holy in the everyday. Rite and celebration are good companions through the seasons of grief, waiting, transition, and starting-again. The visual language of colour, shape, and texture can help us recognize – and accept – the season of life we're in. A painting or a sculpture, a piece of fabric art or an art video, can also give us something to hold on to while we move into the next season or phase of life.

ART AND ARTISTS

Lithurgical Year Cycle B; 2000
LOIS HUEY-HECK
Oil on paper and wood; 15 x 133 cm

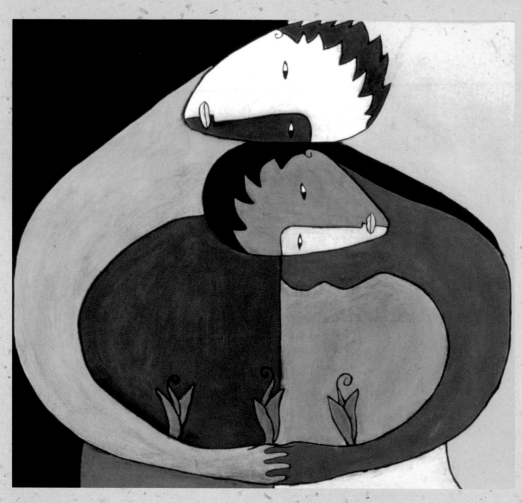

Waiting; 1992
SANDRA ZEISET RICHARDSON

The Christian Year begins with Advent – the season of expectant waiting. Sandy Zeiset Richardson's image *Waiting* is both earnest and playful. The stylized couple is intent on the possibility held in the circle of their joined arms and hands. The egg-shape is evocative of pregnancy and it takes both of them to make this space. I love the whimsy of the three green shoots that sprout from their tender embrace. A colorful and decorative piece, it evokes a clear feeling of attentive waiting. It is almost as if the couple is willing the birth by the power of their concentration. Quoted in *Seasons of the Spirit*,[4] Sandy says,

Waiting implies faith, putting oneself on someone or something else's schedule, being attentive, anticipating the unknown, which, when it comes, in its own time, seems to be somehow familiar, something new that we recognize, remember, have known but forgotten.

In her book *In Wisdom's Path: Discovering the Sacred in Every Season*, Jan Richardson tells the story of being at an Advent gathering in the San Pedro Chapel. The group was shown a slide of a watercolor painting by Sister Doris Klein, C.S.A., who shared the following:

In the cave of our hearts...in the fabric of our lives... in the soul of our earth... you continue, O God, to be born.

Sister Doris holds the belief that in each of us is a place where the holy longs to be born. Jan Richardson's image *Cave of the Heart* reminds us of the call of Advent to enter that cave in our own beings. There we are to

trace the images drawn on its walls, to find God lying in the details of our lives, and then to emerge with newfound wisdom to engage in God's work.

The cave-of-the-heart imagery reminds me of the kivas of the southwestern United States. These cave-like structures built into the earth are places of ritual rebirth. Out of the womb/tomb of earth, participants emerge through a small circular opening, as through the birth canal.

Cave of the Heart
JAN RICHARDSON

CHRISTMAS (BIRTH)

The arrival of the new, the birth of the divine in human form is what we celebrate at Christmas. Once coincident with the winter solstice in the northern hemisphere, Christmas is a 12-day season, which starts (unlike the store merchandizing and decorations) on Christmas Eve. In the north, it's a celebration of the return of light to the world, in both the outer and inner landscapes.

Contemporary Christians are wrestling to balance our celebration of light with an appreciation of sacred darkness. The life of the universe began in darkness; our human lives began in darkness; seeds germinate in the darkness of soil. A day (except in the polar extremes) is a combination of light and dark. In the same way that we fixate on youth, we worship light. But life is a mix of light and dark, youth and age, birth and death. Another way to celebrate birth is to acknowledge that it requires darkness. In the southern hemisphere, the birth is celebrated near the end of summer and the beginning of shorter days. Composers and authors are starting to write hymns, prayers, and stories that uphold the goodness of the dark. As seen below, Rembrandt paints light and dark beautifully – his darkness seems to carry a sense of holy presence. In darkness and in light, the holy and the new are birthed into our world.

The two *Christmas* images stand in deliberate contrast to each other. Painted after a trip to Uganda, *African Nativity*, by Ansgar Holmberg, CSJ, shows the holy family not in the customary dark of a cave or stable, but on a pure white background. The only setting except for a chair is the stylized star hanging above the family. The spareness of the setting shows us clearly what the artist thought mattered most – the family and the star. Images like this, which are so out-of-the-ordinary, remind us that the Christ story is for everyone. They also remind us not to get too attached to any single image we hold of Jesus. None of the pictures we have of Jesus and his family were created by eyewitnesses – we are in the realm of mystery, which is a good state for meeting the holy.

The Rembrandt image could easily be mistaken as being Mary and Joseph with the infant Jesus, but it's not the traditional nativity. Titled *Presentation in the Temple (Simeon)*, this is Jesus being presented in the temple as was the custom of the day. The gospel of Luke tells us that there to greet him were two grateful, aged prophets: Anna and Simeon. Not threatening or ominous, Rembrandt's darkness is more like a safe harbor for this infant child, who will ultimately turn the world upside down. This darkness feels holy, protective, and full of the awe and wonder reportedly felt by Anna and Simeon. Rembrandt used ordinary Dutch people of his day as the models for his epic biblical scenes – a device that reminds us that these events are of an eternal nature.

(left) African Nativity
ANSGAR HOLMBERG

(left) Presention in the Temple, 1669
REMBRANDT VAN RIJN

105

EPIPHANY (CELEBRATION)

Epiphany Day is celebrated on or near January 6 in the Western church. As a festival day, its colors are white and gold and its symbols are the star and the spreading light.

The epiphany we celebrate is the spreading of Jesus' message of radical love. It is a breakthrough in understanding, which is why we call a fresh insight an *epiphany*. The message of love and vulnerability came as a radical alternative to the models of power handed down from the ancient world, including Greek *rationalism*.[5] This message, and love itself, was extended beyond the original community. In a time of intense tribalism, this was a radical idea. In our day – of rabid nationalism and allegiance to the cruel god of corporate interest (tribalism in a suit), and vested religious interest on all sides – this message of radical love and inclusion is still profoundly counterculture. It's one of the main things that keeps me hanging on as an *emerging paradigm* Christian, when I have been discouraged by the damaged and destructive aspects of the faith.

The Day (or Feast) of Epiphany is when we remember the story of the Magi, who follow a star in the heavens to find a baby born in humble circumstance. We hear about these visitors from the East, people from another culture altogether, who come, in the words of Bruce Sanguin, to *pay homage*.[6] Appreciating the open way in which the Magi approach this event he writes,

The Magi notice "a star at its rising." The symbolism is important. Here we have a wise people scouring the night skies, not for signs that they have the Truth, but for signs of the truth wherever the truth might choose to show itself.

Bruce Sanguin's words and Nalini Jayasuriya's image are good companions.

Nalini Jayasuriya has lived throughout Asia and currently resides in Sri Lanka. Her fresh painting of the Magi story is titled, *Magi Bringing Gifts of GOLD for the KING, Frankincense for the PRIEST, and the DOVE of PEACE for the Whole World*. She says she comes from a part of the world "where Hinduism, Buddhism, Christianity, and Islam work, worship, and hope together."

Befitting the visit of the Magi, Nalini describes her painting process by saying, "I follow the night, not into its darkness, but into its stars."[7]

In rich saturated color and sumptuous decoration, Nalini's female Magi come bearing the two familiar gifts of gold and frankincense, and also the *new* gift of the Peace Dove instead of the burial herb, myrrh. Artists and other prophets can do this – turn our perceptions upside down and open us to the new things God can do. The season of Epiphany (the period between January 6 and the beginning of Lent) is an opportunity each year to attend to the places where I have closed my heart to others who believe and see differently.

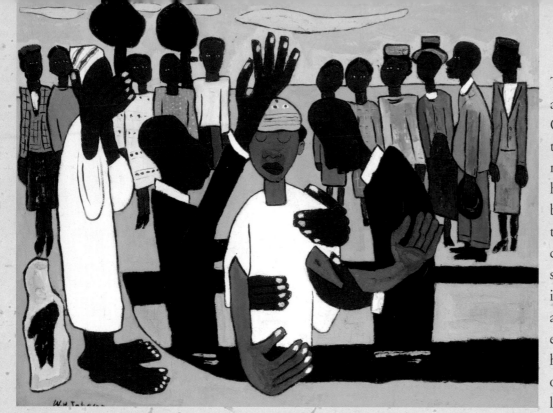

I Baptize Thee, 1940
WILLIAM H. JOHNSON
Oil on burlap; 96.9 x 115.6 cm

The baptism of Jesus is an important event in the Christian Year. It marks the beginning of Jesus' ministry of teaching and healing, which crossed boundaries of race, nationality, gender, and social status. In Johnson's seemingly simple painting, the oversized hands are commanding in their expressiveness. These are hands a person can count on — you could put your life in the hands of this community and never be let down. For all the bright color and rhythmic line, there is a sense of this being a suspended moment, a moment when time stopped.

The Season of Epiphany is one of two seasons in the Christian Year called *Ordinary Time.* The color of the season, as distinguished from the day itself, is green, which reminds of us of growth in the natural world.

At the start of the Season of Epiphany, Jesus is baptized in the Jordan River by his cousin John. As with Rembrandt, the artist who painted *I Baptize Thee* (William H. Johnson) painted the people he knew best. Johnson was one of the Harlem Renaissance painters from New York City (1920–1940). He trained in Europe, but brought his own style and distinctive palette to his images of African American experience. Again, one of the main points here is that "the Jesus event" carries truth that will not be contained within any one culture or time frame. This also applies to the truth of other traditions. As much as we may wish to say *where* and *when* and *how*, the Spirit will not be contained by the walls we construct.

In real time, it's only a few short weeks from the optimism of Advent, Christmas, and Epiphany, to the hard days of Lent. From the spreading of the light and the increase in popularity of Jesus' teachings in Epiphany, the stories begin to shift. The more popular Jesus and his counterculture message become, the more the powers and principalities of his day perceive him to be a threat. As a result, the risk to Jesus and his followers increases dramatically.

In response to the biblical narrative and to the injustices of our day, we are asked to enter a time of reflection and penitence.

This is not a ridiculous call to sacrifice for its own sake. This is about choosing a more frugal and contemplative lifestyle for six weeks in order to have more resources to share. This time is also meant to prepare spirit and soul for the trials to come. For Jesus and his followers, the risks included imprisonment, torture, and death. For us, the risks are more likely to be a changed lifestyle or a loss of popularity – although there are people among us today who risk their livelihood, and in some cases their lives, by speaking out against injustice.

LENT
(SELF-EVALUATION)

Retreat Reflection, 2003
LOIS HUEY-HECK
Photograph

Ash Wednesday is the kick-off event of the season. Although it's a vital part of the year in Catholic churches, it was mostly ignored in the churches of my childhood (an example of how the Reformation threw the baby of transformative ritual out with the bathwater of corruption and hollow observance). On Ash Wednesday, last year's palm branches (symbol of the palms people waved when Jesus entered Jerusalem at the beginning of the final week of his life) are burned, mixed with oil, and used to make the sign of the cross on the forehead. The ritual of the ashes says to me that even though I make a show of saying *Welcome, welcome!* to the sacred, I am also quick at times to turn my back on the needs of others. I am reminded of the adapted lines from Shakespeare that have appeared on environmental posters and cards:

Forgive me, oh broken and bleeding earth, for I have been silent with your butchers.

So I wear the ashes – not very publicly I admit – a small smudge on my forehead, to remind me of my complicity in the poisoning of the earth and the suffering of her creatures. I wear the ashes because they remind me that I want to live differently. The choices each of us make have an impact for better or for worse.

Ash Wednesday, like all of Lent, also reminds us of our mortality – ashes to ashes, dust to dust. Consciousness of our own birth and impending death is one of the things that sets us apart from the other species on the planet. So we face the metaphorical dying of self-interest/ego, but we also do our best to face the truth of our mortal lives. The fact that we know we are mortal causes us great angst at times, but it can also urge us to serve what is bigger than ourselves, and inspire us to make the most of this precious gift of life.

The image *Your Window Pain is the Eye of Pleasure* is over ten years old and the title came to me one day when I was troubled about a woman I care about deeply. Lee is a beautiful and intelligent woman who had a very rough start in life. Her birth parents were barely more than children themselves when she was born and their circumstances were very difficult. When she was 18 months old and ill, her mom reluctantly gave her into foster care. We know now that the adoption of First Nations children into all-white homes and communities caused a rift in the soul of many of those children and their first communities. But, collectively, we didn't know it in the 1960s, when Lee was being shunted from home to home. She was seven years old when she was adopted by a well-meaning family. By then she had lost both parents, every sibling, friend, and home she had known – in other words her entire world – five times. It's a staggering amount of loss for a little girl – or boy – to endure.

This is the collagraph plate – a hand-made printing *plate* with raised and lowered surfaces. The prints I tried to make were all disappointing – none of them captured the pathos of a beloved human being "lost to us and to herself" through addiction. *Window Pain* refers to the fact that while her suffering can be seen from the outside, there is still a hard – sometimes seemingly impenetrable – wall of glass between us. It's the wall of physical distance, emotional distance, and lifestyle. The "eye of pleasure" is the opposite of the "eye of the storm", where all is calm. The eye of pleasure is the abyss at the core of activities/substances that appear to be all about having fun. It refers to all of us. We all know our inclination to turn away from what is painful, and if you were a little girl who suffered neglect, abuse, and staggering loss all by yourself, confronting the pain in your soul would probably be overwhelming.

This title and image are not meant as judgment. They came more as a teacher, an acknowledgement of one of the truths of suffering. The only way to make any kind of peace with the demons that haunt us is to turn and face them. It's hard work and we need a lot of care in the process. For the past five months, I've been trying to make my own heart *right* so that I can try again with Lee. This is a piece of Lent I carry with me always. A grief and sense of complicity

Your Window Pain is the Eye of Pleasure; 1996
LOIS HUEY-HECK
Collagraph plate; 29 x 23.5 cm

for her and for the First Nations children in the Americas and all over the world, who have been taken from their families, their lands, and their cultures and spirituality.

The Jesus of Holy Week and of Good Friday is a Jesus who can identify with human suffering. This is the Jesus that understands what it is to be the victim of injustice, what it means to live in a human body, and what it is to be vulnerable.

Friend and mentor Ralph Milton recommended including Grünewald's *Isenheim Altar*. The famous altar was painted for monks of the Antonite Order, a hospital order. Medieval hospitals were isolated from the larger community and when people entered they were not expected to come out. This is the context for Matthias Grünewald's altar, considered by many to be the single greatest work of Christian art. It is not only Grünewald's technical skill that makes this a masterwork, but also his compassion for those who suffer, and for the monks who gave their lives to care for them. This way of seeing Jesus – as sufferer – was new. Prior to this time, most images of Jesus portrayed him as the victor.

Grünewald wove together the story of the crucifixion and the plight of those enduring horrible suffering with St. Anthony's Fire, a common ailment of the time. St. Anthony's Fire was a condition that caused the distended belly and limbs, and the outbreak of open sores, which are seen both in the figure to the lower left of the panel, and in the figure of the Christ in death, as seen in the bottom panel. Through these paintings, Grünewald sought to comfort the suffering, and their caregivers, by connecting their story to the larger story of the Christ.

On one of the opening panels, we see Jesus transformed in the moment of death, rising into heaven, where he begins to merge with light. Gerald Hobbs says that, in this image, Jesus "ties together heaven and earth."

In the near-death atmosphere of medieval hospitals, this assurance of Jesus as fellow-sufferer, as triumphant in the afterlife, and as connection to heaven may indeed have provided some comfort to the afflicted.

Ralph comments,

I find myself moved and taken by the personality in every one of the figures. Other art of the time tended to portray virgins, bad folks, etc. – types rather than individual people. My strongest reaction is to Mary of Magdala, whom I've always been fascinated with. She shows such strength, even though she's in agony. And there's almost a playfulness in the beasties tempting St. Anthony. While they are horrible, they are almost lovable. Even with the sufferer in the lower corner, there is a sense of not taking it too seriously. This is a piece one could look at for years.

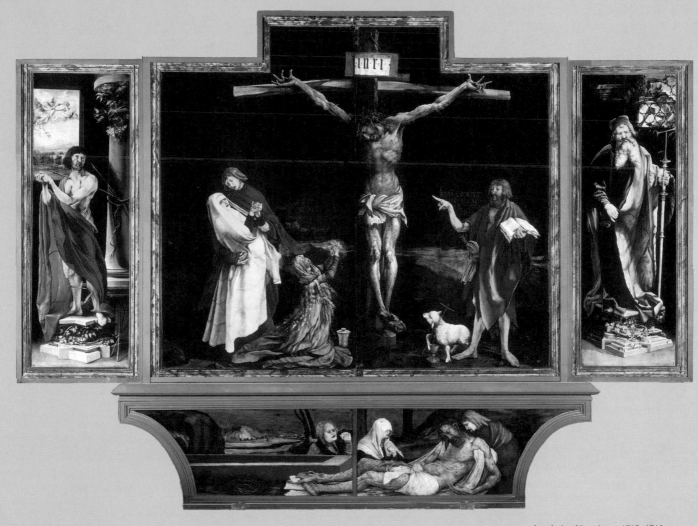

Isenheim Altarpiece; 1512–1516
(from left to right: St. Sebastian,
Crucifixion, St. Anthony)
MATTHIAS GRÜNEWALD

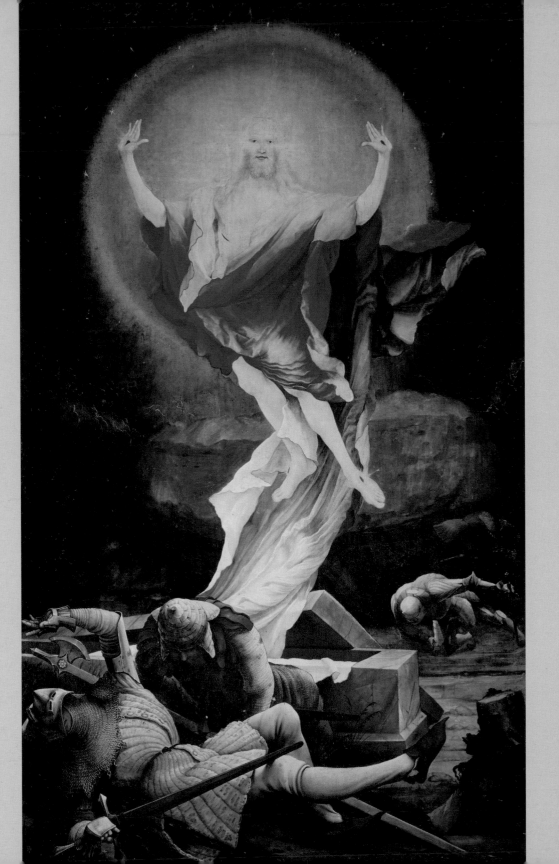

Isenheim Altarpiece
Resurrection
MATTHIAS GRÜNEWALD
269 x 141 cm

114

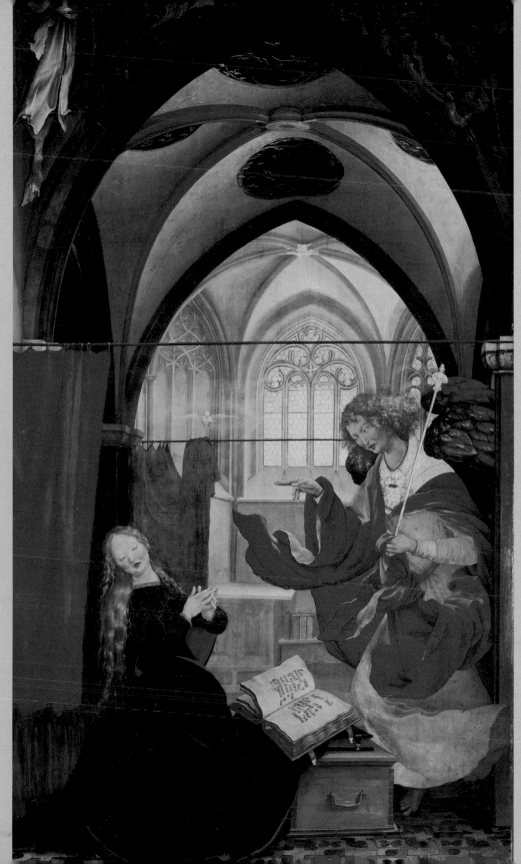

Isenheim Altarpiece
Annunciation
MATTHIAS GRÜNEWALD
269 x 140 cm

115

HOLY WEEK (LOSS)

Lent culminates in Palm Sunday, followed by Holy Week, which includes the Last Supper, Good Friday, and the vigil that brings us to dawn on Easter Sunday morning. The color of Lent is purple. In Lent, we recognize that when the going gets tough, many of us *fall away*. I become aware of the ways I fall away from my responsibility as a global citizen. When I am overly self-indulgent, I am not helping to feed the hungry. When I drive where I could walk, or travel when it could be avoided, I am not helping our failing ozone layer. My personal list goes on, but Lent is not about self-flagellation. It is about an annual, intentional, self-evaluation for the purpose of transformation – a transformation of self into someone who acts more fully on behalf of all of creation. That, I believe, is how we act on behalf of the sacred.

left:
Crucifix in Hong Kong
LOIS HUEY-HECK
Photograph

right:
Crucifixion
GEORGES ROUAULT

EASTER (RESURRECTION/REBIRTH)

Easter is actually the main event in the Christian Year, although for many people that isn't obvious since Christmas gets so much attention! Easter is a high festival and lasts for 50 days – not just one Sunday. As a high season, the colors are gold (or yellow) and white. The colors and symbols are all the celebratory signs of new life.

It delights me that Easter is the last major Christian festival the date of which is set by lunar events rather than by the solar calendar. Easter is the first Sunday following the first full moon after the spring equinox. The moon is yin (feminine and dark) to the sun's yang (masculine and light) character. As with many festivals, Easter has its roots in pre-Christian traditions and the timing, symbols, and feel of the season are similar to these earlier traditions in many ways. Far from finding this troubling, it affirms for me that human beings from many cultures and times in history have experienced the holy in comparable ways.

Abstract Sunrise; 1990
JIM KALNIN
Pastel and charcoal on paper;
50 x 66 cm

117

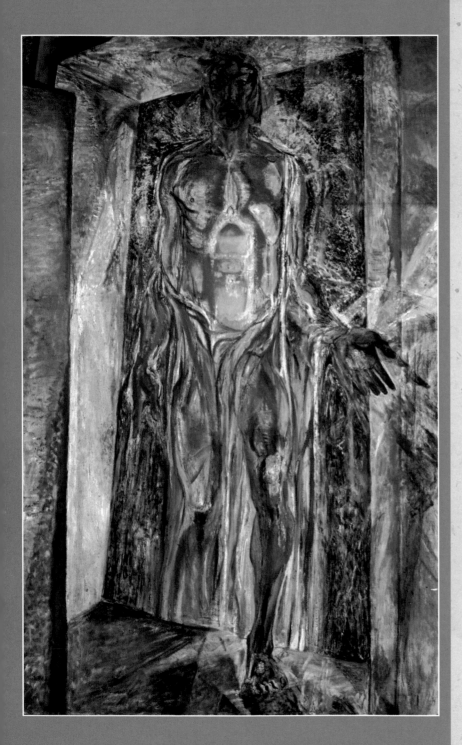

Painted in 1936–37 Frederick Varley's *Liberation* uses intense color and expressive, almost raw application of paint to convey his "unshakeable belief in the spirituality of human beings."[8] Varley saw both himself and Christ in the enigmatic figure coming straight out of the picture frame. He wrote about the painting to his son John in 1937:

The extraordinary thing about it is I know it is paint on canvas — savagely piled on — bare canvas in parts — charcoal — pastel in other parts — and yet it isn't paint at all — no one sees paint. They only see a six-and-a-half-foot figure coming out of strange color lights, an evanescent something which in a moment more will be solid matter — molten metals and jewels. I can scarcely believe that I truly have something impossible to lose or wreck.[9]

Liberation; 1936
FREDERICK VARLEY
Oil on canvas; 213.7 x 134.3 cm

The *Resurrection Sculpture* by Jerzy S. Kenar is located on the grounds of the Spiritual Life Center in Wichita, Kansas. Born in Poland and now living in the United States, Kenar has works in over 100 places of worship. He sculpts mostly in wood, bronze, acrylic, and stone. *Resurrection* is granite, stone, and living water. The cleft in the rock, discarded grave cloths, and stream of water pouring from the split in the huge granite slab tell the story of death-overcome. The black granite base is rough-hewn on the end but the top is polished smooth so the trees and sky of the natural setting are reflected in its surface. The piece is a glorious juxtaposition of hard stone with the changeable natural landscape it mirrors. Kenar's work is a prime example of how eloquently the formal elements of art – material, shape, surface, and color – can speak.

Resurrection Sculpture
JERZY KENAR
Sculpture

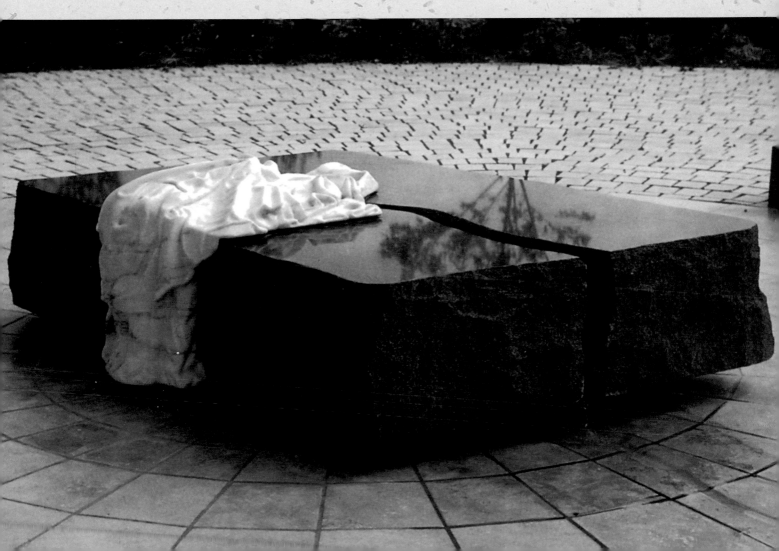

Christianity does not ask us to live in the shadow of the cross but in the fire of its creative action.

TEILHARD DE CHARDIN

Resurrection
ANNE C. BRINK

In striking contrast to Kenar's minimalist sculpture, Anne C. Brink's *Resurrection* is an explosion of color and movement. Here we see the community responding to the good news of the Resurrection with music, dancing, and prayer. The artist says,

The chief concern of my work is to bring hope, healing, peace, and joy to people through art.

The bottom right-hand corner sums up the mood of the Great 50 Days of Easter:

*They put him in a tomb,
BUT IT WASN'T OVER.*

Pentecost is a spectacle of rushing winds and tongues of flame – not consuming flame, but the passion of being on fire with spirit. The worship and the art that I like best are also on fire. The five-elements Tai Chi that I've been practicing for years includes two movements for fire, with some variation on the words,

Fire: our connection to the core of the earth. Fire: all passion and energy. Extend fire in positive action in support of life.

This is the flavor of Pentecost fire – it is spirit given energy for the healing of the world. Because the Holy One meets us individually and in community, we are fired up to live the radical love and inclusion that Jesus lived and taught. While I know that it matters greatly to some, to me it matters not how literally or metaphorically we understand Pentecost. What matters is that we are willing to catch fire for the values we believe in. For me, it's good to have graphic reminders each year that this is how dynamic spirituality is meant to be.

I chose these drawings of Jim's because they are more about the dynamic that is Pentecost than anything I could find by that name. I know from my attempts to draw and photograph the energy of dance that it is not easy to convey movement in a static medium, but these pieces almost sweep themselves right off the page.

Anima Rising #2; 1988
JIM KALNIN
Oil pastel on paper; 56 x 76 cm

121

122

While Pentecost is actually just one Sunday, it is followed by the longest season of the Church Year, which takes up the theme of the human community being in-filled by the Spirit and continuing the ministry of Jesus. Now it's our turn to feed the hungry, heal the sick, visit the prisoners – in other words, to do our part to mend the world. The alternate name for this season, which lasts almost half a year, is *Ordinary Time* because there are no special feasts or events in these months. Like the other *Ordinary Time* season (Epiphany), the color is the green of growth in the natural world.

For someone like me, who feels right at home with the inner world of dreams and images and who enjoys an introspective and personal spirituality, this half of the year is a challenge. I take comfort and encouragement from the words of Howard Thurman:

Don't ask what the world needs. Ask what makes you come alive, and go do it. Because what the world needs is people who have come alive.

Ordinary time is most of the time – it's how we live in response to the seasons of hope, birth, celebration, honest self-evaluation, loss, resurrection/rebirth, and the spiritual mountaintop experiences that have come before. Everything that came earlier in the year has been food and preparation so that we can do our part.

Labyrinths are an ancient metaphor for the seasons of life. The forward and backward, twisting and turning path of the labyrinth reflects the course of living. Seasons and stretches of going straight ahead are punctuated by unexpected turnarounds. In life, as in the labyrinth, we often think our destination is right around the corner only to find our path twisting away and taking us back almost to where we started. But if we stay with it, we get to the center and back. Like the labyrinth, the seasons of life aren't a maze designed to confuse us, but a path for our souls.[10]

opposite:
Anima Rising #6; 1988
JIM KALNIN
Oil pastel on paper; 56 x 76 cm

FOR AN ART/SPIRITUAL PRACTICE CELEBRATING THE SEASONS OF LIFE, VISIT THE WEBSITE: WWW.SPIRITUALITYSERIES.COM

Labyrinth
LOIS HUEY-HECK
Photographs

You beckon, but oh so gently

I can feel your shimmer in my soul

I want to reach in,

extend out, stretch up

And draw down.

umbrella

BITTER

6 Art and Community

JIM KALNIN

Growing up in an agnostic yet loving family, I have never been part of a church community. I missed out on this sense of belonging and feel as out of place in church as most people do in an art gallery. Lois, on the other hand, grew up with the church as a big part of her life and is still nourished by this aspect of community. She comes alive singing in a choir, and loves the rituals and ceremonies that only make me squirm.

While it is possible that this lack of churchgoing in my formative years helped me become independent and self-sufficient, eventually I realized I also had a need for community support. Because art became my main interest and focus, it was with the artistic community that these needs were mostly filled.

Artist's Trading Cards
top left to bottom right:
DEE, SHAUNA ODDLIEFSON,
JIM KALNIN, JIM KALNIN, BEE,
LOIS HUEY-HECK
Mixed media; approx. 9 x 6.5 cm

As an art student, however, and for years after, these needs were not apparent. Nor did I think much about various kinds of community or what they might mean to me. This changed drastically when I traveled alone, for long periods of time, in other lands and cultures. Watching closely, though not participating in, extended families and villages in Guatemala, Thailand, and Ecuador, I saw how people connected in various ways to support each other. This was unlike anything I knew from my sheltered life in Canada. On these extended travels, I found myself unconsciously attempting to create community. Whenever I stayed anywhere for a while, I would paint. The locals and other tourists would sometimes get inspired and make art too. I encouraged and even taught them, and before long we would be pinning small paintings to adobe huts or palm trees, and dragging people to our "openings." Thus began my career as a community art organizer.

Dialogue; 1989
JIM KALNIN
Charcoal on paper; 76 x 107 cm

When I moved to the southern interior of British Columbia, I spent my first seven years living in a small community in the mountains. Here, everything I had learned about cooperating with others was put to the test. We were snowbound a few months each winter, until we managed to buy a derelict snowplow to keep the logging road open. Deep levels of self-awareness, conflict resolution, honest communication, and learning to create our own reality were some of the things we worked on as the snow piled up. By comparison, the summertime challenges – bears in the compost pile, mosquitoes everywhere, and the fact it was just too cold to grow tomatoes – were much easier to manage. In the short summer, the peaceful and beautiful wilderness we lived in worked its magic on our souls.

Although most of my friends there had no art background, they were all eager to learn and to collaborate. Our annual Winter Solstice Pageant and other group projects offered me my first opportunities to put spirituality and art together.

When I left the mountains for the city below, I took with me a well-developed sense of my place in and my need for community. Connecting with the local art scene and teaching at a university gave me many more opportunities to explore working with others for a common cause. Being part of developing art organizations, putting up exhibits and starting an artist-run center were natural extensions of the group processes I learned from my time in the mountains. Both of these experiences have filled my life with challenges, opportunities, friendship, and feelings of accomplishment. Exactly what one might expect of community.

Putting out the Fire, 1989
JIM KALNIN
Charcoal on paper; 79 x 107 cm

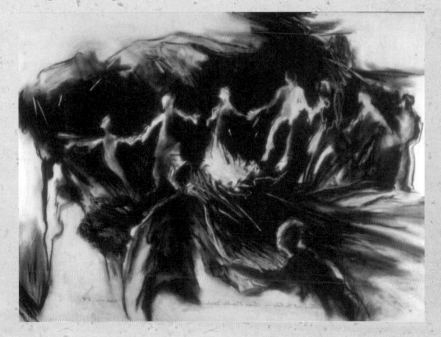

This chapter will focus on some ideas and events that help build community within the art world. Ways in which art and artists function in the overall community are discussed in several other parts of the book.

In 1975, on an extended trip to the highlands of Guatemala, I sat in the bar after a meal, along with a number of other young travelers, and watched as musicians who had just met each other started jamming. Before long, they found enough commonality to start playing well together. Within an hour, they became a decent band and close friends. I lamented to others the fact that artists couldn't just get together like that.

Years later, when I was just learning to play a harmonica (and having to constantly ask what key we were in) I did have this kind of music experience. It was on Gabriola Island, after watching some Quebecois musicians perform. I was visiting a friend when these musicians walked in and I stood back as they greeted each other. Then the guitar player sat on the floor and started into a blues riff. I sat down beside him, suddenly knowing what to do and even what key he was in. Half an hour later we stopped, stood up, hugged each other, then introduced ourselves. I wanted to experience this kind of rapport with visual artists. With my discovery of collaborative art many years later, this wish finally came true.

My first major collaboration was with Lois and our friend Byron Johnston. In 1995, we were invited to build a site-specific installation at the grunt gallery,[1] in Vancouver. We met a number of times to plan our project. I had previously found a partially burned fiberglass canoe on a logging road near our home. The proposed collaboration at the grunt seemed the perfect place for it. Between the three of us, we evolved the idea of treating this vandalized and discarded boat with the care and respect that we felt it deserved. We intended to re-create it, to elevate it from garbage into art. Byron fashioned a sling for it from sheet aluminum and polypropylene rope. While he was hanging it in the gallery, just above average eye level, Lois and I completely covered the walls of the room with homemade charcoal. We also suspended a wooden periscope and mounted an aluminum ladder on the wall, both as aids to viewing the details of the still-damaged boat.

We titled our installation *Re-creation* and felt that the act of working together in a cooperative and creative manner was spiritually re-creating us as well. The boat

floated serenely between the charcoal covered walls. The room took on an ethereal quality that reminded me of both a temple and a tomb. The simple, wood periscope Byron made hung near the boat as it turned slowly and gracefully in space. This project did indeed remind me of the magic that happens to musicians. We made something that had each of us in it, but that none of us could have made alone. Collaborating meant that we each gave up some control of our art. It meant having faith in each other, and in the unknown. This can be a fearful thing, but letting go of that fear is incredibly liberating and empowering. I was now hooked on collaboration.

The burned boat could very well have nine lives. Its career as an installation art project continued the next spring, when we were invited to participate in *Collaboration*, at the Centre des arts actuels Skol in Montreal. Six artists from our area collaborated in teams of two. Byron worked with another artist while Lois and I reused the burned boat with other materials in a new installation. In our artists' statement for the exhibit, we wrote,

Life is a dance of opposites; creation and decay are the dance partners. Out of death and decay spring new life. The boat in the exhibition is as good an example of that as any... The shroud above the boat consists of 950 braided and crocheted strands of recycled dry cleaner garment bags. Lumber, black polyethylene, slide projections of fire, a small fan, sand and water (are) used in the installation... The resurrected boat is clumsy, awkward in appearance, yet also ethereal and graceful, as is the dance of life.

I really enjoy taking non-traditional materials that have been vandalized and discarded and elevating them into things of beauty. The act of transforming garbage into art is my visual act of protest against the rampant consumption and waste that we, the affluent countries of the world, indulge in at the expense of the rest of the planet.

Having ranted in this manner before, we did our best to recycle all the installation materials after the exhibit, and felt guilty at not totally succeeding. The boat is still with us, stored in its crate waiting for the next phase of its life. Perhaps as art, possibly as a flower bed. Either way it will stand, at least in our minds, as a symbol of the continuation of life and as a reminder that all of life requires our care.

An artist is a nourisher and a creator who knows that during the act of creation there is collaboration We do not create alone.
MADELEINE L'ENGLE

untitled collaboration (detail); 2001
LOIS HUEY-HECK & JIM KALNIN

129

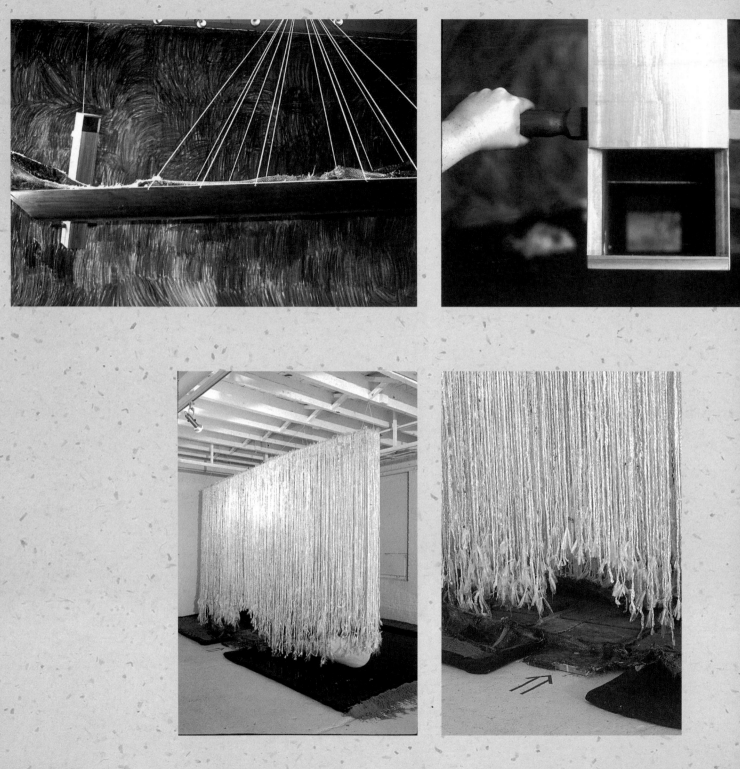

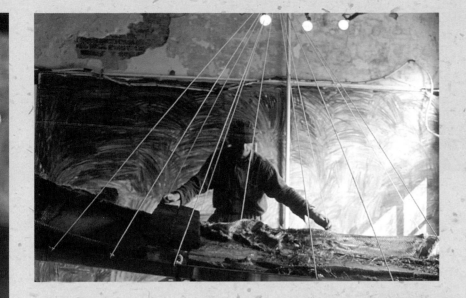

Re-creation; 1995
**L. HUEY-HECK, B. JOHNSTON,
J.KALNIN**
Mixed media

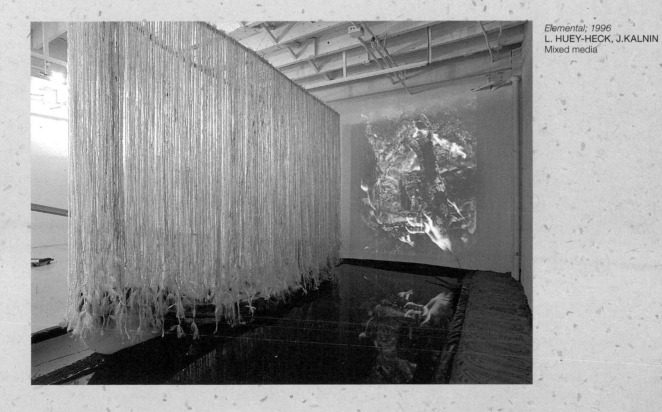

Elemental; 1996
L. HUEY-HECK, J.KALNIN
Mixed media

Collaboration exists in various forms, according to need. As well as installation art, collaborative paintings and drawings are also made; sometimes formally, often casually. Throughout the art world, groups use collaboration as a means of mutual support. One such group is the royal art lodge.[2] Most of the people in the group were art students together in Winnipeg and started drawing with each other regularly as a way of relaxing and relieving the stress of their individual careers. Michael Dumontier, Hollie Dzama, Marcel Dzama, Neil Farber, Drue Langois, Myles Langois, Jonathan Pylypchuk, and Adrian Williams have all been members at one time and most of them still meet and collaborate on drawings on a regular basis. Typically, one person starts a drawing then passes it around the room. Others add whatever they want. A relaxed atmosphere and high level of trust in these sessions allow their art to grow in new directions, with some surprising and refreshing results. At the end of each session, they review the drawings and sort them into several suitcases. The suitcases full of the best drawings then comprise future exhibits.

This draw-something-and-pass-it-on technique really does require participants to check their egos at the door. I have participated in such work often enough to see the benefits of letting go. The success of the royal art-lodge as a group and as individuals is only one example of the potential of such collaboration.

A variation of this approach happens when two or more artists work on the same drawing or painting simultaneously. My most enduring, productive, and enjoyable collaboration was of this kind. My friend and colleague Doug Biden and I made an extended series of black and white monotype prints over a two-year span. Doug teaches printmaking at UBC Okanagan[3] and with his technical expertise guiding us

hope; 2000
ROYAL ART LODGE
Mixed media on paper; 28 x 21.5 cm

we were free to be as expressive and playful as we wished. We would start each session by covering a large zinc plate with black printers' ink. Then we would draw marks or images into it by scraping ink away, and later by drawing back into the image. Sometimes the ideas would develop slowly and hesitantly; at other times, the drawings flowed effortlessly.

Sometimes we would request certain images from each other. Occasionally, we changed or even eradicated each other's work. At first I had difficulty with this, but eventually learned to trust both Doug and the process. Throughout the drawing process, we would talk, joke, laugh, and generally goof around. Doug and I have the ability to bring out the kid in each other, which brought high energy to the work.

untitled; 1997
ROYAL ART LODGE
Mixed media on paper; 21.5 x 28 cm

JAN. 19, 1997

Transition Zone; 2000
DOUG BIDEN/JIM KALNIN
Monotype print; 60 x 90 cm

The monotype *Transition Zone* is a representative example of the art we produced. It embodies our deep concerns for the health of the natural world, while expressing our joy in life. Many of the prints express our concerns with order, balance, and sustainability. The interdependence of all life is expressed in a number of other works in this series. This piece and *The Pass* are two of my favorite images. Partly that's because they illustrate the points made in our statement, and partly it's because of their poetic quality, which evokes a sense of the spirit behind the form.

Working with another, like-minded artist adds new dimensions to the act of art. My own work has changed in a number of ways as a result of these collaborative experiences. Others report having gained from similar experiences. We all have the ability to teach and to learn from each other. When Doug and I worked on the monotypes, we criticized, cajoled, and encouraged each other; that dynamic simply became part of the working environment. Any bruises to our egos have long since healed, leaving us with a lot of good memories and a satisfying body of work.

The Pass; 2000
DOUG BIDEN/JIM KALNIN
Monotype print; 60 x 90 cm

MAIL ART

The mail art movement that has evolved recently is one that naturally builds community. It is completely inclusive in nature. Those who find the political and commercial machinations of the art world overwhelming will find the idea of mail art attractive. Artists and art groups put out calls to other artists, advertising the dates and location of an exhibit, usually through the Internet, art newsletters, and posters or flyers. The art is generally not judged, criticized, bought or sold, and no one's art is rejected. All art mailed in by the deadline is exhibited, usually in an alternative gallery space. Some groups will return the work, while others do not – read the instructions carefully. Some of the more established mail art organizations, many of them based in Europe, will even print catalogues or burn CDs of some of their exhibits.

I got a crash course in this phenomenon when Dan Anhorn, one of our senior fine arts students, asked me to help him curate a mail art show on the theme of "Bicycles," in our department's small art gallery. We sent out the call (or rather, Dan did; I mostly watched as he orchestrated the event) and before long, packages started arriving from every corner of the planet. A lot of packages. We had to literally wallpaper the gallery with entries in order to exhibit them all. We even got a full-sized bicycle with parts reassembled and with a very complex paint job. The quality of the submitted work was uneven, of course, but when we installed it all the overall effect was a busy yet cohesive collection of imagery that gave the plain little gallery a festive feel. Some of the packages were works of art in themselves and so we exhibited them too. The show was a huge success, attracting many people who normally didn't come into the gallery. For me, the show, and the act of creating it, was a reminder of the large community of artists to which I belong.

opposite:
Bicycle painting
ANONYMOUS
Mixed media on paper; 11 x 17 cm

opposite:
Bicycle drawing
ANONYMOUS
Charcoal on paper; 9 x 12.5 cm

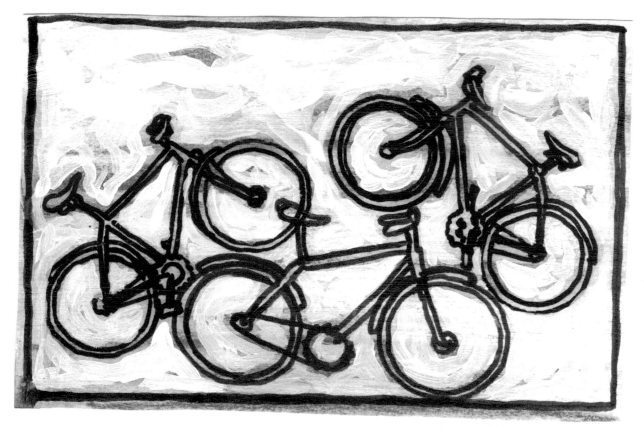

ARTIST'S TRADING CARDS

Another form of community-oriented, democratic art that grew, more or less, out of mail art is the artist trading card movement, or ATC as it is commonly known. This rapidly spreading art-happening started somewhat accidentally in Switzerland, spread through Europe and over to Canada, and is now a global phenomenon. Artists in local communities make small original works of art (usually 2.5 inches by 3.5 inches, the same size as printed sports trading cards) and trade them to each other at regularly held meetings. Like mail art, this is a process anyone can participate in. The art is traded, usually one for one, not bought or sold. Trades are generally not refused.

Artist Margo Yacheshyn brought this idea to our community and set up workshops and trading sessions through the Alternator Gallery, a local artist-run center.

After much encouragement by Margo, Lois and I both got involved. Working on this very small format, with no expectations to ever exhibit or sell the work, is liberating. The ability to make art with no real pressure on us allows us to experiment to a greater degree than we would normally do in our larger work. Like collaboration, trading art cards can lead us to new and refreshing art. Also, there is a quality of innocence and joy at these trading sessions that is a refreshing change from the professional and academic

*Artist's Trading Cards
left to right:*
MARGO YACHESHYN,
JULIANNA HAYES,
LOIS HUEY-HECK,
MARGO YACHESHYN
Mixed media

138

art worlds. Although I am a part of those worlds and gain much from them, I also enjoy the simplicity and purity of trading my small artworks for those made by artists of all ages. There is a spiritual quality to the open and democratic exchange that happens at these sessions. I also feel more connected to the art community locally and globally when I participate in these events.

The ATC movement, like the rest of life, keeps growing and changing. Artists trade globally as well as locally, and touring exhibitions are now taking place. There are also buyers and sellers of artist's trading cards, countless websites, and chat groups. The day when we find them in major art galleries may not be far off, as this grassroots movement is now becoming part of the structured art world. Change is inevitable and on one level I welcome it. I do intend, however, to continue happily making these tiny pieces of art for as long as I can find someone to trade with.

The three forms of interactive art that I have looked at here represent only a few of the many ways established artists support each other. Mail art and artist's trading cards also open the community of artists up, to include the creativity and participation of new and aspiring art-makers.

FOR AN ART/SPIRITUAL PRACTICE RELATED TO COMMUNITY VISIT THE WEBSITE: WWW.SPIRITUALITYSERIES.COM

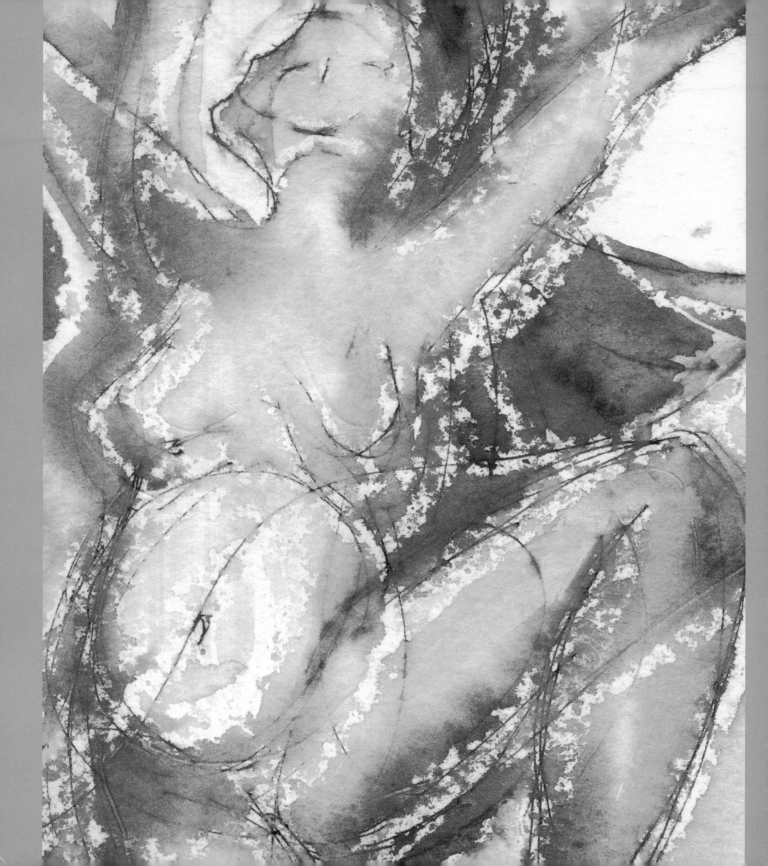

7 Art and the Dance of Life

Lois Huey-Heck

The great dance of birth, life, death, and regeneration is the way of life itself. In the West, we've been estranged from our endings and our beginnings. My dad was not allowed to attend the birth of any of his children. He had to drop my mom off at the hospital and she had to endure – and celebrate – some of the greatest and most challenging events of life without her partner, or anyone who loved her. Sadly, we lived like that for several generations, as our birthing and dying were taken out of our homes and put into institutions. It has made us a neurotic people – afraid of the very stuff of life. Fortunately this is changing, as we reclaim our beginnings, endings, and the passages in between. Reconciling ourselves with the grown-up realities of life is a process – the work of a lifetime.

The Dance of Changes, 1999
LOIS HUEY-HECK
Watercolor; 20 x 25 cm

Of course, life isn't only about crisis and the burden of knowledge. Sometimes life is a banquet – a feast for our senses. Byrd Baylor's *I'm in Charge of Celebrations* is one of my favorite storybooks. Told from the perspective of a girl-child, the tale witnesses to the importance of celebrating every moment of life. Not just the obvious things like a birth, but other important things like finding a hawk feather, the longest day of the year, and a certain quality of light in a sunrise. It's a curious dynamic, but our ability to face the hard parts of life is directly proportionate to our ability to experience joy. And we are called to live it all as fully as possible, say the great spiritual teachers. Fortunately there we have lots of opportunities to practice!

During its birthing, this chapter had many names, including *Art and Celebration*, and *Art and the Rhythms of Life*. All the titles are metaphors – ways of describing and picturing something *more*. The *more*, in this case, is something we humans wrestle with (or try to avoid) much of our lives – the passage of *time*. It is the consciousness (unique to humans so far as we know) that our lives in these bodies, on this utterly amazing planet, are finite. So this chapter might also have been called *Art and Time*, but I believe the metaphors I've named are much more evocative. As Marion Woodman says,

Shakespeare didn't have to write, "Out, out brief candle," of Lady Macbeth's end. He could just have said, "She died," but we would have been much the poorer for it.

Psychologist John Hughes says,

I contend that saying "Hello" and saying "Good-bye" are the two major learning tasks all humans need to accomplish.[1]

SAYING HELLO: CONCEPTION

There were many painful years before Julie Elliot was able to conceive and carry a child to term. It was during one of those intense times of waiting and hoping that Julie created the works *Cycles of Count, Count of Cycles*. She says that creating these drawings was not only cathartic, but the research she did on fertility in order to make the drawings provided her with the knowledge that ultimately led to conception. They are large drawings on soft paper with incised lines, raw marks, soft smudges, and erased passages. The charcoal she used is by nature dramatic, but also fragile, vulnerable. *Ultrasound* is about the joy of seeing the ultrasound that confirmed the first of two healthy pregnancies. It's hard now to remember Julie and Jim's home without Bryce and Sara.

Julie Elliot; 1989
ULTRASOUND
Mixed media on paper

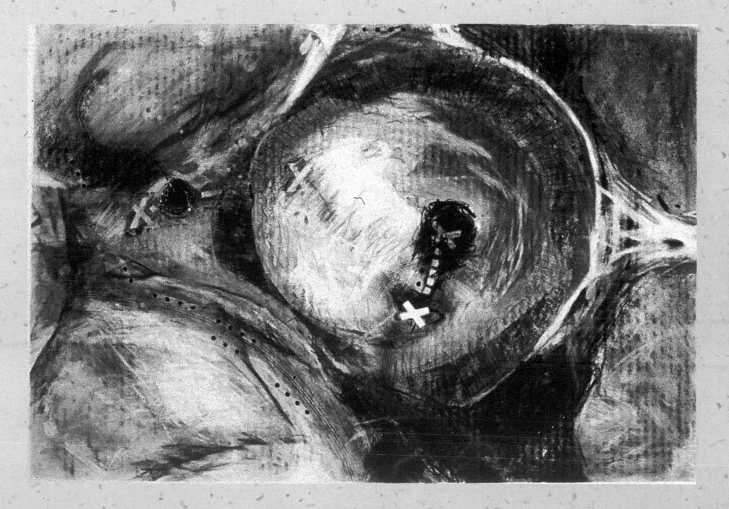

SAYING HELLO:
REBECCA'S BIRTH

Music – Pink and Blue II; 1919
GEORGIA O'KEEFFE
Oil on canvas; 88.9 x 74 cm

Ingrid and husband lived in Australia when their daughter was born. Back in Canada, Ingrid's sister Chris wrote a letter of celebration:

The boys walked with me
 to the fields today
This day that your child arrived.
It was one of those glorious days in May
When one is glad of just having survived
Those gloomy months of snow and sleet
When the sun never seems to grow warm.
Now the air is laced with scents
 that are sweet,
The perfect time for a girl to be born.

Chris continued her tale of how she and her sons had taken a shovel on their walk, planning to dig some of the blue columbine they'd noticed earlier. She says they danced with delight on turning a corner and finding a field of blue violets that seemed to go on forever. Chris continues,

I thought of Rebecca and wondered if she
Would have eyes that were so deep a blue.
Soft, warm and cuddly
 I knew she would be
With the scent special to babies
 brand new.
And I remembered a Mother's Day
 of not long ago
When we went through the fields
 together.
Two little girls with our father to show
How to pick violets to give to our mother.

SAYING YES TO LIFE:
JIM'S BIRTHDAYS

Jim has a great tradition of celebrating his birthday by making art. For him, making art on his birthday is not only joyful, it also affirms him, and his passion for creating, creativity, and creation itself. For Jim, it is all sacred – all of one piece (one of the things I love most about him). Jim's mixed-media image of coyote floating through space is a self-portrait. He says,

It's a portrait of me and the universe. I am both lost in it and connected to it – at home.

Drift; 1996
JIM KALNIN
Mixed media on paper; 81 x 102 cm

145

SAYING HELLO: PARTNERSHIP

For me, no one paints the bliss of falling and being in love like Chagall. He is so full of joy that he – and his beloved – can't keep their feet on the ground. It reminds me of a first-year English class, where the professor was trying to teach us how to understand metaphor. One novel included a description of falling in love that was heady and thrilling. When the professor asked the class, *Who falls in love like that?* he was met by blank stares. *Everyone!* he bellowed with exasperation. *Falling in love should feel like that for everyone!*

The Birthday; 1915
MARC CHAGALL
Oil on canvas; 80.6 x 99.7 cm

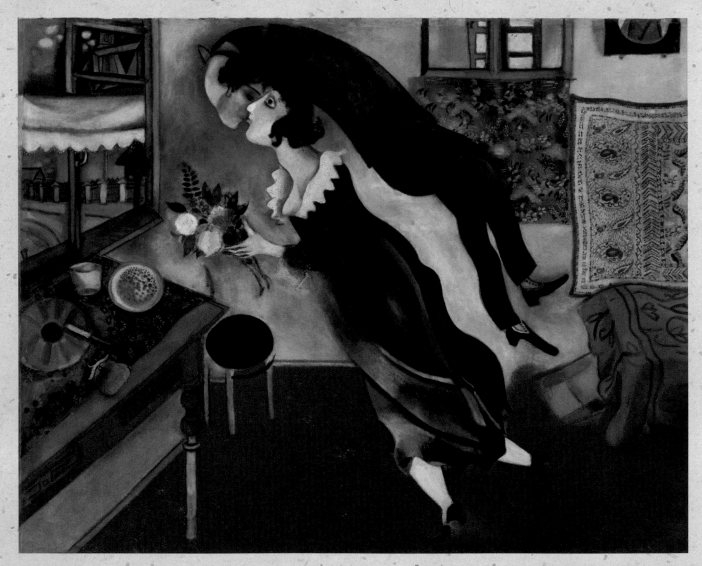

146

Chagall knew and felt it and he put it into paint. We, too, can take delight with him in the ecstasy of being in love with someone who loves us back. His painting is titled "The Birthday" and was painted the year he married his long-time love, Bella. Chagall said of Bella,

All I had to do was open my window and in streamed the blueness of the sky, love and flowers with her.[2]

Chagall's painting style is often referred to as poetic. He offers interesting perspectives, rich expressive color, and great visual metaphors. In *The Birthday*, we see Chagall *over the top*, happy to be with his love at last.

When Jim and I got married, a group of women artists and friends[3] gave us *cards* they'd made. Each one is a delightful, original piece of art like the two shown here. Phyllis Scarfo's piece is closed with a tiny gold key and opens to reveal *his* and *hers* night shirts hanging on one of Phyllis' signature clotheslines. It's whimsical and romantic, with just a little dose of the practical reality of getting the laundry done.

Julie Elliot's *The Wedding* uses gold thread to emphasize the connecting lines of relationship. Between the golden beaks of the birds, she stitched a wonderful tangle with gold beads representing the vows spoken and made at the wedding. It's a visual metaphor for relationship and for promises made.

THE WEDDING

SAYING GOODBYE: LEAVING HOME

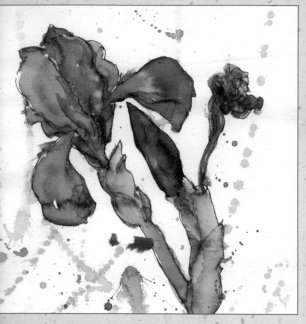

Iris; 1995
LOIS HUEY-HECK
Watercolor; 19 x 21 cm

Teya has just bid farewell to her daughter Sharra, who has gone to Europe with friends. Teya and Elizabeth are the last two of a circle of friends – the *River Sisters* – to see their last child leave home. All of us *first generation* river sisters have now been through it. When Sandy's girls left home, we started meeting monthly to support each other through the many transitions we were facing. Sandy gave us the phrase *bittersweet* to describe how it feels to say goodbye to grown children. This circle of friends has given encouragement to Betsy through a challenging ending; inspiration to me as I returned to studying and art-making; and has celebrated Sue's daughter in a wonderfully alternative wedding shower, and at her marriage. As you'll read in Marilyn's poem *When a Woman Knows*, we also support and celebrate each other's birthdays.

I call us the *River Sisters* because we've been meeting – along with partners, children, and various pets – at a river for over a dozen summers. During the days we camp together – more time together in a few days than we get in a whole year – our relationships deepen. It's sacred time. The river itself is a steady reminder of constancy and change. This past summer I was particularly struck by how lucky I am to have this extended *family* of sisters and daughters (and brothers and sons!). We will continue to learn from each other across the generations. We midwife each other into new stages of living.

My iris paintings most often show the bloom in three stages. I discovered the pre-patriarchy triune goddesses Mother, Maiden, and Crone[4] at about the same time I noticed that, in the height of the season, you can find an iris bud, a full-bloom flower, and finished blossom all on one stalk. So I started drawing and painting those moments in honor of the feminine and natural life processes – the dance of life. I find each stage of blooming to be beautiful in its own way. I will not shy away from the word or concept *crone*, nor will I see something or someone old as being ugly or useless. This particular iris is offered in thanksgiving that we can be girls, young adults, mothers, aunties, and even someday grandmothers together.

SAYING HELLO TO 50

Fifty is a lot younger than it used to be, but in our youth-worshipping culture (may we grow out of this bizarre obsession before it is too late!) it is a significant marker. The image of the dance of life and the beauty of maturity is reflected in Marilyn Raymond's poem. Many artists love to depict dancing – it's the metaphor as much as the beauty that attracts us.

When I think about art and dance, it is Henri Matisse's 1909–10 painting *La Danse* that first comes to mind. Through his use of color, curved line, and fluid shapes, Matisse's art seems to dance – even some of his still life paintings. This well-known image is not so much about dancers in the literal sense, but uses the dance as a metaphor for life. The painting has a mythical quality that seems made for this theme.

Not very well known, Rodin's watercolor sketches of dancers are full of energy and movement. He kept his models moving in his studio so that he was forced to make quick, gestural impressions of their movements. The loose overlapping lines and simple color heighten the sense of movement and remind us that the nature of time is to keep moving.

Cambodian Dancer; 1906
AUGUSTE RODIN
Watercolor

Fat Woman Dancing: The Dance of Changes is one of many works I've done over the years on the theme, *Freedom is a Fat Woman Dancing.* For a woman of size, to dance freely and vigorously is an act of cour- age in our culture. The loose painting style and expressive color are meant to celebrate and encourage us all in our perfectly imper- fect bodies to *know how beautiful we are.*

Freedom is a Fat Woman Dancing;
1995
LOIS HUEY-HECK
Mixed media on paper;
each panel 20 x 35.5 cm

WHEN A WOMAN KNOWS
MARILYN RAYMOND

It is winter
 and I am fifty.
Nine women have gathered in a small cabin
on the edge of a frozen lake –
 to sing and dance and laugh away
 this awkward reality.
We have walked on the ice in the moonlight
and laughed our way through dinner.
We have soothed fifty with new red lipstick.
In this small, warm room
I have pulled away from myself
 and I am watching the women dance.
A room full of beauty – tangible as blood.

It breaks your heart wide open
 when a woman knows how beautiful she is.
At fifty, young men's eyes slide over us like water.
Graying hair, lines on our skin,
the pull of gravity,
 turns us into background,
 into echoes
But it breaks the seals from your eyes
 when a woman knows how beautiful she is.

She dances with the fluid sensuality of long experience
and deep memories of love.
She moves like the tides,
 like heartbeat.
Fifty, they say, is sliding into old
The end of the line
 the end of youth and passion
 the end of flirtation and wild physical being
 the end.

But it lifts the barriers from your mind
 when a woman knows how beautiful she is
Her confidence, the sexy movement of her dance
the lift of her shoulder and the tease in her hips.
Experience textures her
layers her with movements with context and consciousness.
She dances her life story.
She fills the room with power
 when she knows how beautiful she is.

Outside tree branches sketch sharp wrinkles
 and soft shadows against the snow.
The year is old,
 but we are only fifty.

> *There is a river of creativity running through all things, all relationships, all beings, all corners and centres of this universe. We are here to join it, to get wet, to jump in, to ride these rapids, wild and sacred as they may be.*
>
> MATTHEW FOX

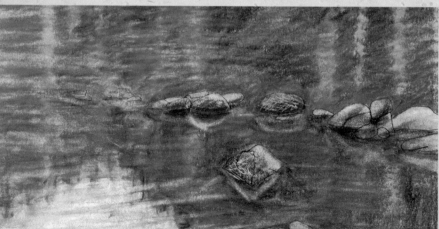

untitled; 2004
LOIS HUEY-HECK
Mixed media drawing; 19 x 28 cm

TRANSITIONS: SAYING GOODBYE TO SUMMER

Part of this chapter was written in a cabin beside a chain of mountain lakes. My family has a tradition of camping and fishing on the Labor Day weekend that goes back to when the first of the grandchildren were young. Even though some of us don't actually fish, we look forward to this time together. We walk and paddle, laugh and argue, celebrate my brother Keith's September birth, read, sing, take photos, and draw. This weekend marks the end of summer, the return to school, and the beginning of autumn. The days are noticeably shorter and at the high mountain lakes it's already freezing overnight – a graphic reminder that winter is coming. This past year only the youngest of our children made the trip, the oldest ones are now working or living "away." So we also mark this other season – the season of grown children. We move out of the glorious weather that is summer in western Canada and prepare for the reality of fall and winter. Being together and being close to the land eases the transition between the seasons – natural and familial.

SAYING HELLO: LANDSCAPE/LIFESCAPE

The year Tim and Donna Scorer turned 60 they bought a painting from a favorite artist, Perce Ritchie. In Perce's signature style, the colors are soft and there's room for the viewer's story to fill in the details. Tucked into the back of the painting is a letter Tim wrote to Donna. Tim relates how the image tells some of the story of their meeting, and how it describes the current season of their life together.

In 1965, when you were 21, a chance encounter brought us together on a train crossing the Manitoba prairie toward Saskatoon. You and I chose to turn that moment of chance into such a path of intention that now, as we enter the decade of our 60s and look back to that Saskatchewan meeting, we see a fascinating landscape that has roots and color in the prairie, but detail and meaning from all those places of sense, imagination, and intimacy that we have included in our shared journey of nearly 39 years.

It's a beautiful letter that continues by celebrating the fullness of life Tim and Donna have enjoyed and by offering gratitude for "the abundance of life that flows from that commitment," including the couple's three grown children.

They are as much a part of this land-scape of love and sacredness as we are. They have been present in this frame of family for as long as we have. Now they stand apart, living into other frames of relationship, drawing on their own met-aphors and choices… There is a space between the two (on the right) and the three (on the left) – a hint of rail lines or lines of light, boundaries of a sanc-tuary spacious enough for partners and grandchildren, and for generations that might choose to be included in a thread of a story we picked up together in a place where sandy prairie met the blue-gray of eternity in 1965.

Compline Saskatchewan;
PERCE RITCHIE
Oil on canvas

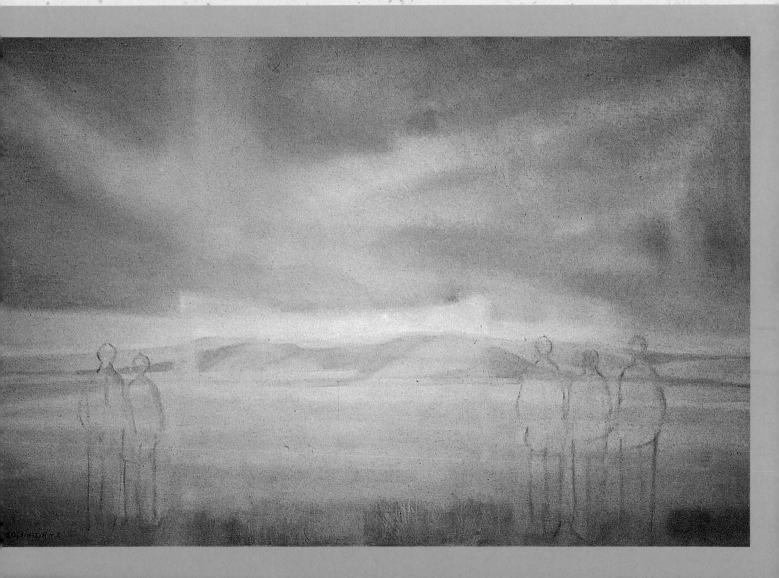

SAYING GOODBYE: POMEGRANATES

Last year it was Thanksgiving weekend when I found the first California pomegranates in the store. We'd stopped for groceries on our drive home from spending the weekend in the Rockies with our son. That moment launched a flurry of art-making. I returned to my journals and found the pomegranate poem that had come to me a couple of years previously, when I was grieving.

There's a long tradition of symbolism associated with pomegranates,[5] but these pieces are mostly about the seeds of possibility.

POMEGRANATE

I planted my pomegranate today.

Under, deep under, the foundation of the chapel. A quiet place.

Round, rich, ruby red.
Full of seeds is misleading.
A pomegranate is seeds in a thin red leathery pouch.
Symbol of fertility.

I was literally going to bury it
in the ground.
But sitting here in the chapel this morning

just living
grieving, celebrating
crying, laughing
singing, sitting
scheming, being
observing, feeling
allowing…

it became clear;

it wasn't about digging a literal
hole-in-the-ground
near the labyrinth, even,
into which to offer the symbolic burial
of my 20-year-gone uterus.

I wanted it/it wanted to be
under the foundation
of the chapel.

Where its seeds can
germinate
with the other germinations of this sacred place.

left:
Pomegranate V; 2004
LOIS HUEY-HECK
Oil on canvas; 26 x 31 cm

right:
Pomegranate VII(detail); 2004
LOIS HUEY-HECK
Oil on metal; 26 x 31 cm

Where it can be honored
while giving something, too…

I plant my seeds here.

Kneeling in the center
of the circle
placing my seed bed
deeper, deeper.

Tear-water
Heart overflow
Hands firmly placed palms down.

Kiss the spot.
Act of love.
Act of faith.

Nothing ever ends completely.

Oh, there are deaths
to grieve,
but they are not the final end.
They make room for new things to be
born.

We are not strangers to loss
and it is necessary
to know the gut-wrenching,
shit-kicking reality of true grief when it
comes.

And then… plant seeds.

What else will our tears water?

untitled; 2004
LOIS HUEY-HECK
Mixed media drawing; 21 x 62 cm

155

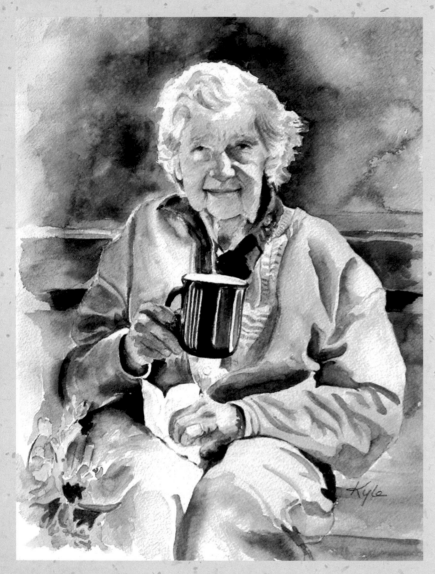

Tea on the back steps; 2004
MARGARET KYLE
Watercolor on paper, 55 x 37 cm

SAYING GOODBYE: ENDINGS

Two friends lost parents while we were writing this book. Margaret Kyle's mom, Louise, was about the sweetest person you'd ever hope to meet. Margaret was grateful to be with her mom during her last hours. At the memorial service, she talked about how she felt with her

the spirit of all her brothers and sisters, as she remained by her mother's side. Margaret paints beautiful, sensitive watercolor images that are a festival of color, light, and shadow, and it was wonderful that the portrait she'd done of her mom was smiling back at us during the service. There was a palpable sense of love and presence in the work.

Robert Nachtwey was the beloved father of our dear friend Elizabeth. Dr. Nachtwey lived a life of service. After a trip to England in 1980, he returned to the U.S. convinced of the need for hospice care. He believed that all people should be able to die with dignity. His colleagues told him it could never be done. Gentle, kind, and soft-spoken Robert simply responded, "It has to be this way," and so it was. Bob gave his life's work to ensuring quality of life for the people who came to Springfield, Illinois. He also knew most of the people on the staff by name and treated them with respect and dignity. At the funeral, a woman told Elizabeth that when she was a fresh graduate from nursing school, Dr. Nachtwey had made a point of asking her opinion on a patient. She said that she was speechless, to be treated with so much respect by an eminent physician. As people poured in to pay tribute to a man they admired greatly, they literally told hours of stories.

Fittingly, Robert's last days were spent at home, where he had the constant companionship of his wife, Mary, of nearly 60 years, and then of his children and grandchildren. He held on until the day after the youngest of his ten children arrived. Elizabeth tells of his passing.

We did vigil around his bed for the week, each day another sibling arriving. We sang songs, read poetry, picked flowers, and whispered all the things that we ever needed to tell him… Julie [the youngest of the ten Nachtwey children] *arrived on Monday and he passed on Tuesday. The actual moment he left his body was truly amazing. It was 90 degrees and still, muggy and humid all week, and around 4:00 the wind picked up, we opened the windows in his room and the front door blew open, papers blew around like moths on his desk — it was surreal. There was a single crack of thunder and he took his last breath. The wind promptly died down and the children covered his body with flowers and we sang and prayed and laughed and cried. He was one powerful man!*

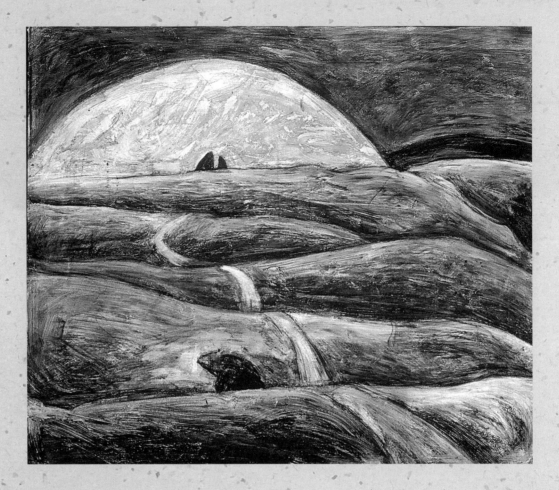

Dryland; 1996
JIM KALNIN
Acrylic on canvas; 89 x 120 cm

Obviously, this is not a story about a painting or a piece of art in the usual way we think of art. This is a story that *is* art. It's a stunning example of the art of a life well-lived – and well-ended. Elizabeth says that helping people die with dignity was the reason her dad came into this life. He lived his destiny fully – for others and in his own dying. Does this mean there were no tears, no grieving? Of course not. It was Elizabeth who taught me that we grieve, we have tears, because we know love. And love is definitely worth it.

A vital quality of the rituals and celebrations we employ is that they have the potential (often neglected in the "modern" world) of bringing us face to face with the deep questions of meaning. Issues of meaning are gateways to the Source. To face the reality of birth, life, and death – no longer clinging to some adolescent fantasy – is to mature into the fullness of our being, embrace our divine destiny, and accept our individual responsibility to serve life. The seeds that Robert Nachtwey planted continue to germinate, sprout, and bring forth new life.

It is the end. It is the beginning.

It is the cycle of birth, sustenance, death, and regeneration, lived in its full beauty, pathos, and elegance. Amen.

FOR AN ART/SPIRITUAL PRACTICE RELATED TO THE DANCE OF LIFE VISIT THE WEBSITE: WWW.SPIRITUALITYSERIES.COM

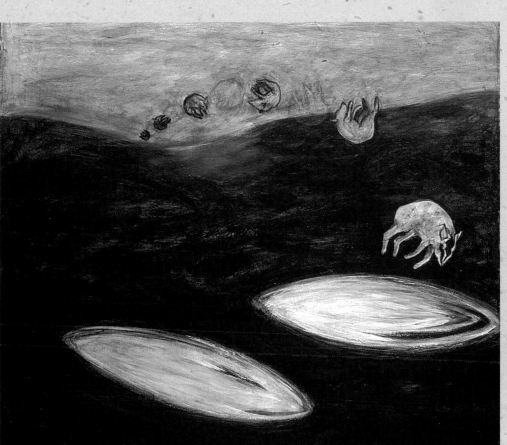

Revival; 1995
JIM KALNIN
Acrylic on paper; 124 x 163 cm

The pendulum swings, and swings back.
For every action, here will be an equal and opposite reaction.
So we are born, and eventually we die.
We plant seeds in the spring, and rip out the roots in the fall.

Killing and healing tread on each other's heels.
Buildings go up, and get torn down,
and new buildings emerge from the ruins of the old.
The Phoenix rises from its own ashes.

You lose someone you love, and in grief you bounce like a ping pong ball
between tears and hysterical laughter.
If despair were forever, you couldn't carry on,
but you carry on because you know that despair will someday be displaced by dancing again.

You can't make love all the time.
Sooner or later, you have to become friends.

You misplace your house keys; you find them.
You forget someone's name; it comes back to you in the middle of the night.
You lose a job, and a new career opens up.
You spend the first half of your life accumulating possessions, and the second half giving them away.
The animated conversations of young lovers mature into the comfortable silences of long familiarity.
Why should we expect a single state of mind, a single snapshot of experience, to last indefinitely?

Does a pendulum stop at the end of its swing?
So war and peace,
love and hate,
togetherness and aloneness,
cycle and recycle…
Life is full of little resurrections.
Why should we doubt the bigger ones?

ECCLESIASTES 3:1–8 PARAPHRASE BY JAMES (JIM) TAYLOR

Phoenix rising; 1989
LOIS HUEY-HECK
Acrylic on canvas; 90 x 61 cm

160

CONCLUSION:

The Art of a Life Well Lived

JIM KALNIN

Through the chapters of this book, we have been expanding the definition of spirituality in art to include a wide range of ideas. For many people, art means painting, drawing, or sculpture. Contemporary art is constantly changing that definition. Although this can be confusing, it can also be liberating. The more aspects of life that we include in art, the more likely we are to see our own lives as works of art. When we include found-object installation and performance art in our definition, how can we then leave out children's art, folk art, or art made in less technological or academic cultures? And if Inukshuks qualify as art, then how do we view snowmen; or rock, seashell, or driftwood assemblages in our yards? Though they may not reach the expectations of the established art world, allowing this kind of creativity into our lives can do wonders for our souls.

untitled; 1998
BRYAN HECK, LOIS HUEY-HECK, JIM KALNIN
Beach installation

Building figurative sculpture out of large spheres of snow and using our bodies to create pictures of angels in the snow are not very far removed from what contemporary sculptors like Andy Goldsworthy do with wood, rocks, and ice. His creative responses to the materials of the natural world help us deepen our understanding of the power and beauty of nature. Learning to engage with the material world on a playful and creative level for ourselves can take us further. It can remind us that we are of the earth, part of the dance of creation. The art we are looking at in this chapter is mainly of the non-traditional variety. Most of it never got into art galleries and much of it was made by people who do not see themselves as artists. We hope it inspires and encourages you.

CHILDREN'S ART

Given a reasonably healthy environment, children will readily make art. Their attempts are almost always full of joy. The children's art included in this book is by young people we know and love. It is representative of children's art everywhere, both in its pure expression and in its display of the children's willingness to try out new things. They naturally draw well, as can be seen in Bailey Riddell's tree drawing (page 173). They also adapt easily to other art disciplines. The linoleum block print by our son Bryan Heck and the etchings by Hillary Biden and Nick Biden show their willingness to try out sophisticated techniques. Watercolor painting is often an intimidating medium for most adults. Nathan Mikkelson's first attempt at it was inspiring to watch. He loaded the paint onto the paper with brushes and thumbs, and with an eagerness and determination that is refreshing to see in artists of any age. Bryan attacked his first acrylic painting with the same kind of abandon. These kids are not aware of the intimidating myths that surround certain kinds of art.

Heart Painting; 1985
NATHAN MIKKELSON
Watercolor on paper; 10.5 x 13.5 cm

clockwise: *Bodycluster*
HILLARY BIDEN
Lithograph print; 30 x 31 cm

Coyote, 1992
BRYAN HECK
Acrylic on paper; 51 x 61 cm

Lucky Charms
NICK BIDEN
Lithograph print; 30 x 25 cm

Vulcan, 1990
BRYAN HECK
Linocut print; 7 x 9.5 cm

A LINE
IN THE SAND

Line in the Sand
LOIS HUEY-HECK
JIM KALNIN

We are all aware of the importance of keeping some joyful exuberance as we grow. Perhaps this is the real secret of eternal youth. Lois and I try to encourage playfulness in each other, and to keep it alive in our art practice. Watching her draw *Fat Woman Dancing* on the vast expanse of sand in Pacific Rim National Park was a reminder to me that art really does exist in all aspects of life, and that the daily dance of life is where it belongs.

ART OF FAMILY

When she built a more formal mixed-media installation in an art gallery, Lois managed to keep a playful element in the work. In a very different way from her small works, it was also a celebration of the dance of life. Her exhibition *Ancestry: Inherited Intangibles*, at the Alternator Gallery in Kelowna in 1994, took artifacts from her own family history and transformed them into an environment of transcendent beauty. In her artist's statement she wrote,

Old doors, window frames, and rusty metal ceiling panels are some of the great stuff salvaged from a derelict farmhouse. My father's family moved there on the day World War II was declared. My grandmother's embroidery patterns, images drawn onto the backs of old advertising posters, and other recycled papers, my parents' and grandparents' stories were the starting point for the work. The

rubbed, peeled, lifted fragments of my family's past, combined with ideas and symbols of my life today, are more than a sentimental journey. They are a metaphor for the human experience of editing family patterns and personal experience to create an authentic life. It is at once a critique of the family/my family, and an honoring of the same.

As I walked through this installation of real and almost real artifacts, as I walked on a six-inch bed of dry, pungent pine needles through a wraith-like forest of transparent veils, past glowing fragments of Lois' family history, I felt transported. The transferred surfaces of bunkhouse doors and embossed ceiling panels were invested with echoes of the lives that were lived within their embrace. Art reveals the sacred in the mundane, the spirit within everything.

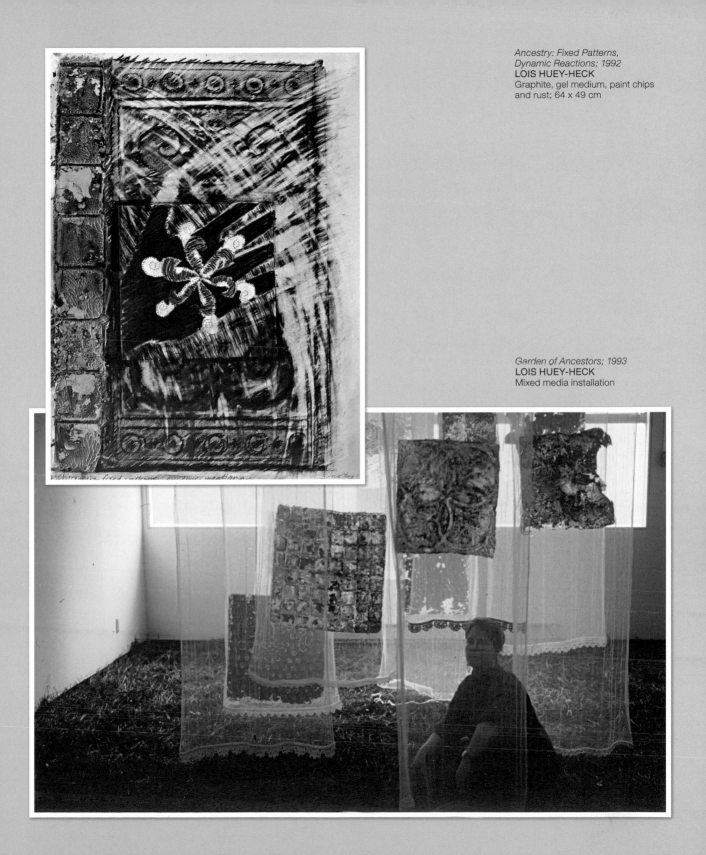

*Ancestry: Fixed Patterns,
Dynamic Reactions; 1992*
LOIS HUEY-HECK
Graphite, gel medium, paint chips
and rust; 64 x 49 cm

Garden of Ancestors; 1993
LOIS HUEY-HECK
Mixed media installation

TWIG TALKING

I began making installation art on my fishing trips. This expanded my studio by several hectares. At the many small trout lakes on the high plateau country near our home, I started collecting organic materials and garbage, and turning it into art. The first of these, at Doreen Lake, involved a dead fish and forensic practices. Canoeing back to my camp by the lakeshore with a small trout I had kept for my lunch, I threw the fish up onto the campground before getting out of the boat. When I climbed out, I noticed it had landed on an old piece of heavily rusted metal. The combination of the two images intrigued me; I thought there might be an interesting social statement in adhering one to the other, but couldn't

think of a way of making the trout stick to the metal. I looked through my box of art supplies – no fish glue in there, but I had a jar of white acrylic paint. With a small stick, I began tracing a thick white line on the metal, around the fish. As I was doing this, it occurred to me that this is what police do with chalk at the scene of a murder, before they take the body away, and that indeed this fish had been murdered, by me actually. I somehow felt it was important for me to see my act of cooking and eating my catch as an act of violence. I felt it was important to be aware of my actions, and to take responsibility for them.

I cooked and ate the small trout, added a few more collected materials to the fish outline on metal, and took it further down the lake in my canoe. I stopped at a small, sunlit clearing, and, using discarded fishing line, tied my construction between two trees, photographed it, and left it behind. That was hard to do, to make a piece of art that was personal and that I liked, and leave it behind. The installation survived for several years, and I had completely let go of it by the time it disappeared. By then I had also made many more wilderness installations.

Incident at Doreen Lake; 1997
JIM KALNIN
Mixed media installation

On Oyama Lake, I started gathering twigs, poles, driftwood, and discarded fishing line on a few of the 26 islands in the lake. On one island, I took the small silvery branches from the tip of a dead, fallen spruce tree, and inserted them into the neatly drilled woodpecker holes in the trunk, creating a rustic fence along the top of the log. I photographed it and went back to fishing. I returned to the spot two weeks later. When I approached the log, I saw to my dismay that the little branches were all gone. I assumed someone had built a campfire on the island and found the perfect kindling in my sculpture. However, when I got closer, I realized that the branches were still there, now piled in two tidy piles, one on either side of the log. Someone had rearranged my assemblage. I was relieved the branches were still there and not at all insulted by the intervention. So I put the branches back in the woodpecker holes and turned each branch ninety degrees, making a different, more open fence on top of the log.

It was quite some time before I once again returned to the island to see if my tree branch conversation with an unknown collaborator had continued, and this time the branches were indeed gone. I have since made numerous such constructions, but have not found any more *twig talkers* out there. I hope that I do.

Twig Installation Oyama Lake; 1998
JIM KALNIN

169

THE TREE OF LIFE

The Watchful Soul
STEVE PERRAULT
Acrylic on canvas on board;
68.6 x 58.4 cm

I met Eric when I spent time in northern California in the 1970s. He told me about his ongoing art dialogue involving a tree, and how it helped him. His marriage was failing, and he thought it would take him down with it. Confused and depressed, he went for daily walks in the hills near his home, trying to sort out his life. Other people walked in those hills, and over the course of a few meetings he got to know one of them, a young woman named Haley. She was also at a low ebb in her life after the end of her own relationship.

Their friendship grew through a simple and innocent act. Eric found a peculiar stone on one of his walks, and took it with him. When he saw Haley later, he gave it to her. She was sitting in a small glade beneath a tree when he found her. She smiled and thanked him for the rock. They talked a little and he continued on. A few days later, he found three small, delicate skull bones, from some forest creature. When he got to the glade, he saw that Haley had nestled the rock he gave her between two roots of the tree where she had been sitting. He placed

the three small bones on top of it and left. On his next visit, he saw that Haley had added some feathers, and another rock. Over the next few months, they still met accidentally on the trails. They talked about their problems and about life in general. Over time, their combined installation grew, spreading up the trunk of the tree and out the branches. Every time Eric went to the tree he found a new surprise. The thing they were making amazed him; it kept growing, effortlessly. He had never seen anything like it. Winter came and at Christmas they left little presents there for each other.

The tree project and their friendship continued to grow. Eric's marriage foundered and died. But he was empowered by his experiences in the forest, laughing, playing and creating something of no practical value, with a beautiful young woman. The experiences helped him return to a place where he liked himself again. They reminded him that life could have magic in it; life could be fun. Although Eric never considered himself an artist, and didn't think of their project as art, he learned that he could be creative. These two people never became a couple. By the time Eric told me this story, Haley had moved away and his life had moved on. But their time together helped them both to heal.

Rainforest
LOIS HUEY-HECK
Photograph

Sundeck
JIM KALNIN
Photograph

I keep thinking of their decorated tree as another manifestation of the Tree of Life. This symbol exists in almost every religion and culture. The images, names, and characteristics given to it may vary, but it always seems to point to the connection between the underworld, the material world, and the heavens. The Tree of Life is also seen as the source of sustenance, vitality, and empowerment, for various gods and mortals. I believe that the tree Eric and Haley decorated was all of these things for them. It sustained them when they were needy, and perhaps even gave them a deeper understanding of the unity of all life, and of all worlds. Archetypal images such as this can affect us unconsciously; we may respond to them without knowing why.

There is a fir tree in our yard where we wanted to build the deck, so we built around it. The tree now acts as a roof over our deck. It is also a home to all manner of creatures that become part of our lives every summer. A grand old pine tree on the other side of the house hovers over our upstairs bedroom window, becoming an extension of our home, and an outdoor theater for the rest of the inhabitants of our yard.

This is the last story in our book, though

the stories we tell all continue on their own journeys, and are intertwined with many other stories. They are tiny branches on the infinite Tree of Life.

Lois and I have presented these stories and pictures as a teaching, and also as a celebration. We hope this book can also be a celebration of the diversity and end-less creativity of life for you. It has been a teaching and an expression of gratitude and joy for both of us.

Anaïs Nin once said:
"We write to taste
life twice." ...
we write to taste life twice,
and we paint and dance
and sing and compose
and do all art
"to taste life twice."
MATTHEW FOX

Tree, 2005
BAILEY RIDDELL
Felt pen on paper; 13 x 11 cm

Endnotes

Untitled
JIM KALNIN
Acrylic and pastel

Introduction

1 Among Don Grayston's many roles/vocations are priest, educator, spiritual director, Thomas Merton scholar, and pilgrim. He is a founder of Jubilee Associates and director of the Pacific Jubilee Program in Spiritual Direction, at Vancouver School of Theology. I heard Don's insight on "slowing down" at the August 2005 residency of the Jubilee Program.

Chapter One

1 Adriana Diaz is the author of *Freeing the Creative Spirit: Drawing on the Power of Art to Tap the Magic and Wisdom Within* (San Francisco: HarperSanFrancisco, 1992). She was quoted in *Seasons of the Spirit*.

Chapter Two

1 Thanks to Germano Celant who used this term in his monograph *Anish Kapoor*.

2 Matthew Fox and Rupert Sheldrake, *Natural Grace: Dialogues on Creation, Darkness, and the Soul in Spirituality and Science* (New York: Image, 1997), 172.

Chapter Three

1 Presbyterian, Methodist, and Congregationalist; and then United Church of Canada.

2 Caroline Ebertshauser, *Mary: Art, Culture, and Religion through the Ages* (New York: Herder & Herder, 1998), from the "Introduction."

Chapter Four

1 Marjorie Agosin, *Tapestries of Hope, Threads of Love: The Arpillera Movement in Chile 1974–1994* (Albuquerque: University of New Mexico Press, 1996), page 76.

Chapter Five

1 The solstices and equinoxes are called the quarter days. The cross-quarter days – which are Candlemas in February, Beltain in May, Lamas in August, and Samhain in October – fall between the quarters.

2 Gertrud Mueller Nelson, *To Dance with God: Family Ritual and Community Celebration* (Mahwah, NJ: Paulist Press, 1986). This book is a terrific companion to the Christian Year for those who want to go beyond the superficial.

3 Our observance of feasts and fasts can degenerate into something we do by rote if we allow them to lose their connection to the numinous. When this occurs, it is appropriate to make change. Unfortunately, in the West, we tend to throw the baby out with the bathwater and the vast majority of us have lost any meaningful connection to rituals that could potentially restore sacred balance to our lives and communities.

4 *Seasons of the Spirit* is a lectionary-based worship, Christian formation and outreach resource for congregations. *Seasons* honors the integrity of art and artists as teachers in their own right.

5 See Margaret Visser's Massey Lecture, *Beyond Fate* (Toronto; House of Anansi Press, 2002) for an erudite and valuable commentary on the positive role of Christianity in offering an alternative to the damaging and prevailing fatalism of our day.

6 Bruce Sanguin, *Summoning the Whirlwind* (Vancouver: Canadian Memorial Press 2005).

7 Quoted in *Seasons of the Spirit*.

8 Peter Varley, *Varley* (Toronto: Key Porter Books, 1983).

9 Ibid.

10 See Gailand MacQueen's book *The Spirituality of Mazes and Labyrinths* (Kelowna, BC: Northstone, 2005) for an excellent investigation of the subject.

Chapter Six

1 The gallery uses only lower case letters in its name.

2 The group of artists has chosen to use only lower case letters in their name.

3 A campus of the University of British Columbia, located in Kelowna, British Columbia.

Chapter Seven

1 Quoted in the Alban Institute book *Running Through the Thistles*, by Roy M. Oswald. With thanks to Rev. Heather Burton for bringing it to my attention.

2 Ingo F. Walther and Rainer Metzger, *Chagall* (Köln: Taschen, 2000).

3 We began as a group of six, all so-called mature students in Fine Arts in the 1980s. We decided we should work towards exhibiting together and decided on the group name, The Sex of Us. (Getting a bank account in our collective name was interesting.) The group grew to include Sharron Culos, Betty Dhont, Julie Elliot, Maureen Lisle, Jane Ritchie, Phyllis Scarfo, and myself.

4 There are other variations of the three-fold goddesses, such as Kali: creation, sustenance, and destruction. For further reading on this subject I recommend Marija Gimbutas, *The Language of the Goddess* and *The Civilization of the Goddess* (San Francisco: HarperSanFrancisco 1988 and 1991), and Elinor W. Gadon, *The Once and Future Goddess* (New York: Harper & Row, 1989).

5 "The pomegranate with its red juice and many seeds was a prime symbol of fertility... therefore [it was]... eaten by souls in the underworld to bring about rebirth." "The Bible says the pillars of Solomon's temple were ornamented with... pomegranates..." Quotations from Barbara Walker, *A Woman's Encyclopedia of Myths and Secrets* (San Francisco: HarperSanFrancisco, 1983), 805–806. "...while in the underworld Persephone had eaten seeds of the pomegranate, a fruit that symbolized marriage." Quotation from *World Book Encyclopedia*, Vol. P, (1996), 294. The pomegranate is one of five fruits mentioned in the Bible.

SELECTED BIBLIOGRAPHY

Agosin, Marjorie. *Tapestries of Hope, Threads of Love: The Arpillera Movement in Chile.* Albuquerque, NM: University of New Mexico Press, 1994.

Berry, Thomas. *The Great Work: Our Way into the Future.* New York: Bell Tower, 1999

Carr, Emily. *Fresh Seeing.* Toronto: Clarke, Irvin & Company Ltd., 1972

Celant, Germano. *Anish Kapoor.* Milan: Edizioni Charta, 1996.

Finlay, Victoria. *Colour: Travels through the Paintbox.* London: Sceptre/Hodder and Stoughton, 2002.

Fox, Matthew. *Creativity: where the divine and the human meet.* New York: Tarcher Putnam, 2004.
––– *One River, Many Wells: Wisdom Springing from Global Faiths.* New York: Tarcher/Penguin, 2000.

Harvey, Andrew. *A Walk with Four Spiritual Guides: Krishna, Buddha, Jesus, and Ramakrishna.* Woodstock, VT: Skylight Paths/Jewish Lights, 2003.

Kuh, Katherine. *The Artist's Voice.* New York: Harper and Row, 1962.

May, Rollo. *The Courage to Create.* New York: Bantam, 1975.

Morris, Jerrold. *On the Enjoyment of Modern Art.* Toronto: McClelland and Stewart, 1965.

L'Engle, Madeleine. *Walking on the Water.* New York: Bantam, 1972.

Sepulveda, Emma. *We Chile: Testimonies of the Chilean Arpilleristas.* Washington, DC: Azul Editions, 1996.

Shlain, Leonard. *The Alphabet Versus the Goddess: The Conflict Between Word and Image.* New York: Viking, 1998.

Sinclair, Donna. *The Spirituality of Gardening.* Kelowna, BC: Northstone, 2005.

Teasdale, Wayne. *The Mystic Heart: Discovering a Universal Spirituality in the World's Religions.* Novato, CA: New World Library, 1999.

SELECTED AUDIO

Tapestry is a weekly exploration of spirituality, religion, and the search for meaning on Canadian Broadcasting Corporation Radio One (CBC). A list of programs is online at **www.cbc.ca/tapestry** and audio recordings can be ordered including interviews with **Thomas Berry, Matthew Fox, Thomas Keating, Robert Thurman,** and **Lucinda Vardey**.

Chodrin, Pema. *Meditation for Difficult Times.* Denver, CO: Sounds True.

Estés, Clarrissa Pinkola. *The Creative Fire.* Denver, CO: Sounds True.

Fox, Matthew. *Lecture on Creativity July 2005.* Vancouver: Vancouver School of Theology.

Woodman, Marion. *Addiction to Perfection.* Denver, CO: Sounds True.

SELECTED WEBSITES

Andy Goldsworthy
www.sculpture.org.uk/artists/AndyGoldsworthy

Anish Kapoor **www.artcyclopedia.com/artists/kapoor_anish.html**

Bill Viola **www.billviola.com**

Medicine Wheel Sun & Stars
www.kstrom.net/isk/stars/starkno5.html

Ministry of the Arts **www.ministryofthearts.org**

Scott Mutter
www.photography-museum.com/mutter/scottmutterNewGallery.html

Paterson Ewen **www.ccca.ca**

The Arpilleristas **www.quiltedconspiracy.com**

The Tree of Life
http://altreligion.about.com/library/weekly/bltreeoflife.htm

Web support for this book is online at **www.spiritualityseries.com**

Seeking Light
JIM KALNIN
Acrylic and pastel on paper on board

CREDITS

Page 9 Anish Kapoor, *Oblivion, 1994*. Courtesy Lisson Gallery and the artist. Used by permission.

Page 10 Bill Reid, *Raven Discovering Mankind in the Clam Shell, Haida, 1970*. Collection of the UBC Museum of Anthropology, Vancouver, Canada (Nb1.488). Photo: Bill McLennan. Used by permission.

Page 13 Mary Smith McCuloch, *Portals, (detail)*. Image courtesy of the Kelowna Art Gallery. Photography by Colin Jewall Photo Studios. Used by permission.

Page 16 Maureen Lisle, *Speak to Me*. Used by permission.

Page 21 Mary Smith McCuloch, *Iona Veil*. Image courtesy of the Kelowna Art Gallery. Photography by Colin Jewall Photo Studios. Used by permission.

Page 26 Mark Tobey (American, 1890–1976), *Broadway*. The Metropolitan Museum of Art, Arthur Hoppock Hearn Fund, 1942 (42.170). Photograph © 1996 The Metropolitan Museum of Art. Used by permission.

Page 27 Adriana Diaz, *Tremor*. Copyright © Adriana Diaz 1996. Phil Cohen, photographer. Used by permission.

Page 28 *Sweeping Up*, photograph of Joseph Beuys, Karl-Marx-Platz, Berlin, 01 Mai 1972, by Jürgen Müller-Schneck. Copyright © Jürgen Müller-Schneck. Used by permission.

Page 29 Nancy Chinn, *Prayer Canopy*. Installation in the Cathedral Church of Saint Mark, Minneapollis, MN, 1993. Photo by Jeffrey G. Smith, as reprinted in *Spaces for Spirit*, Nancy Chinn, Liturgy Training Publications, Chicago. Used by permission.

Page 30 Michel DeCleer, *Tibetan Prayer Flags*, photo by Michel DeCleer. All rights reserved. Used by permission.

Page 31 Edward Piper, *A Winter View of a Sarsen and Trilithon at Stonehenge*. Photograph by Edward Piper. Used by permission.

Page 32 Kenojuak Ashevak, *Arctic Assembly*, Lithograph, 1996. Reproduced with the permission of Dorset Fine Arts.

Page 35 *Inukshuk*. www.photos.com

Page 36 Claude Monet (1840-1926), *Poplars on the Bank of the Epte River*. Bequest of Anne Thomson in memory of her father, Frank Thomson, and her mother, Mary Elizabeth Clarke Thomson, 1954. Philadelphia Museum of Art, Philadelphia, Pennsylvania, USA. Photo credit: The Philadalphia Museum of Art/Art resource, NY. Used by permission.

Page 37 Vincent van Gogh, *Imperial Crown Fritillaria in a Copper Vase, 1887*. Musée d'Orsay, Paris, France. Photo credit: Erich Lessing/Art Resource, NY. Used by permission.

Page 40 Emily Carr, *Forest, British Columbia*, 1931–1932, oil on canvas. Collection of the Vancouver Art Gallery (Acc #VAG 42.3.9), Emily Carr Trust. Photo: Trevor Mills. Used by permission.

Page 41 Lawren S. Harris, *North Shore, Lake Superior, 1926*, The National Gallery of Canada and the family of Lawren S. Harris. Used by permission.

Page 42 Charles E. Burchfield, *Orion in December*. Copyright © Smithsonian American Art Museum, Washington, D.C./Art Resource, NY.

Page 43 Morris Graves, *Bird Singing in the Moonlight*. The Museum of Modern Art, New York, NY, USA. Digital Image © The Museum of Modern Art / Licensed by SCALA / Art Resource, NY. By permission of Robert and Desireé Yarbel of the Morris Graves Foundation.

Page 45 Mark Rothko, *Untitled (Violet, Black, Orange, Yellow on White and Red)*. 1949. Solomon R. Guggenheim Museum, New York. Gift, Elaine and Werner Dannheisser and The Dannheisser Foundation, 1978. 78.2461. Copyright © Kate Rothko Prizel and Christopher Rothko/SODRAC 2006. Used by permission.

Page 46 Jann Arthus-Bertrand, *At the Well*. Copyright © Yann Arhus-Bertrand/La Terre vue du ciel. Côte d'Ivoire, region of Bouna, hydraulic drilling station in a village near Doropo. Used by permission.

Page 49 Bill Viola, *The Crossing*, 1996, video/sound installation. Photo by Kira Perov. Used by permission.

Page 51-52 Andy Goldsworthy, *Icicles* and *Touching North*. Copyright © Andy Goldsworthy: A collaboration with Nature (Abrams, 1990). Used by permission.

Page 53 Anish Kapoor, *1000 Names*. Courtesy Lisson Gallery and the artist. Used by permission.

Page 55 Julie Elliot, *Send My Roots Rain*. Copyright © Julie Elliot. Used by permission.

Page 60 Heiko C. Schlieper, *Theotokos and Child*, icon. The Provincial Museum of Alberta, Canada (H85.1194.1). Used by permission.

Page 68 Judy Chicago, *Sojourner Truth plate*, 1979. Copyright © Estate of Judy Chicago/SODRAC (2006). Photograph, Copyright © Donald Woodman. Used by permission.

Page 69 Judy Chicago, *The Dinner Party*, 1979. Copyright © Estate of Judy Chicago/SODRAC (2006). Photograph, Copyright © Donald Woodman. Used by permission.

Page 71 Salvador Dali (1904-89), *Christ of St. John of the Cross*. Copyright © Glasgow Museum: The St. Mungo Museum of Religious Life & Art. Used by permission.

Page 76 Frederick Franck, *The Original Face: Closed and Open*. Photograph by Luz-Piedad Lopez. Used by permission.

Page 77 Giovanni Bellini (1430-1516) *Madonna and Child*. Accademia Carrara, Bergamo, Italy. Photo credit: Erich Lessing/Art Resourche, NY. Used by permission.

Page 79 Mary Southard, CSJ, 2003, *Divine Light*. Courtesy www.ministryofhearts.org. Used by permission.

Page 80 Michel Tuffery, *Tigiani*. Courtesy of Artist: Michel Tuffery, Wellington, NZ. Used by permission.

Page 82 Bagong Kusudiardja, *Christ and the Fishermen*. From Image: Christ and Art in Asia (Asian Christian Art Association). Used by permission.

Page 84-85 artist unknow, *Chilean Arpillera*. Copyright © Winnie Lira, Executive Director, Fundación Solidaridad. Used by permission

Page 87 Steve McCurry, *Afghani Artisan, Qandahar*. Copyright © Steve McCurry/Magnum Photos. Used by permission.

Page 88-89 Pablo Picasso (1881-1973), *Guernica*. Copyright © Picasso Estate/SODRAC (2006). Copyright © ARS, NY. Photo credit: John Bigelow Taylor/Art Resource, NY. Used by permission.

Page 90 Sue Coe, *War Street*. Copyright © 2003 Sue Coe. Courtesy Galerie St. Etienne, New York, NY. Used by permission.

Page 97 Adriana Diaz, *Sisters of Clouds*. Copyright © Adriana Diaz 1994. Used by permission.

Page 97 Rudolfo Arellano, *The Good Samaritan*. Copyright © Ass. Del desarrollo de Solentiname, Managua, Nicargua. Used by permission. All incomings through this painting from. Solentiname are going to the projects of Father Ernesto Cardenal.

Page 102. Sandra Zeiset Richardson, *Waiting*, 1992. Copyright © Sandra Zeiset Richardson. Used by permission.

Page 103 Jan L. Richardson, *Cave of the Heart*. Copyright © 2000 Jan L. Richardson. Used by permission.

Page 105 Ansgar Holmberg, CSJ, *African Nativity*. Used by permission.

Page 105 Rembrandt van Rijn, *Presentation in the Temple (Simeon), 1669*. National Museum, Stockholm, Sweden. Photo credit: Kavaoler/Art Resource, NY. Used by permission.

Page 107 Nalini Jayasuriya, *Magi bringing Gifts of Gold for the King, Frankincense for the Priest, and the Dove of Peace for the Whole World*. Copyright © Nalini Jayasuriya. Used by permission.

Page 108 William H. Johnson (1901-1970), *I Baptize Thee*, ca. 1940. Copyright © William H. Johnson. Smithsonian American Art Museum, Washington, DC, USA. Photo credit: Smithsonian American Art Museum, Washigton, DC/Art Resource, NY. Used by permission.

Page 113-115 Mattias Grünewald, Isenheim Altarpiece, ca. 1515: *Crucifixion/Resurrection/Annunciation*. Photo credit: Erich Lessing/Art Resource, NY. Musee d'Unterlinden, Colmar, France. Used by permission.

Page 116 Georges Rouault, *The Crucifixion*. The Minneapolis Institute of Arts, Gift of the P.D. McMillan Land Company. Copyright © Estate of Georges Rouault/SODRAC (2006). Used by permission.

Page 118 Frederick Varley, *Liberation, 1936*. Art Gallery of Ontario, Toronto. Gift of John B. Ridley, 1977, Donated by the Ontario Heritage Foundation, 1988, (Acc. #L77.131). Used by permission.

Page 119 Jerzy S. Kenar, *Resurrection Sulpture*. The Spiritual Life Center, Wichita, Kansas. Used by permission.

Page 120 Anne C. Brink, *Resurrection*. See www.annebrink.com for more images. Used by permission.

Page 143 Julie Elliot, *Ultrasound*. Copyright © Julie Elliot. Used by permission.

Page 144 Georgia O'Keeffe, *Musique – rose et bleu II*. Collection of Whitney Museum of American Art, Gift of Emily Fisher Landau in honor of Tom Armstrong. Copyright © Estate of Georgia O'Keeffe/SODRAC (2006). Used by permission.

Page 146 Marc Chagall (1887-1985), *The Birthday (L' Anniversaire)*, 1915. Copyright © SODRAC (2006), NY. Acquired through the Lillie P. Bliss Bequest. (275.1949) The Museum of Modern Art, New York, NY, USA. Digital Image © The Museum of Modern Art / Licensed by SCALA / Art Resource, NY. Used by permission.

Page 149 Auguste, Rodin, *Cambodian Dancer*. Bequest of Jules E. Mastbaum, 1929. The Rodin Museum, Philadelphia. Used by permission.

Page 170 Steve Perrault, *Watchful Soul*. Used by permission.